POSTCARD HISTORY SERIES

Hollywood
Studios

JULY 2010

TO BILL -

THANKS FOR THE
TOUR OF UNIVERSAL AND
ALL THE GREAT STORIES -

GENE
(& ROB7. RICHARD)

A Trip Through
THE
Motion Picture Studios

∽

OFFERED BY THE
Hollywood Chamber of Commerce

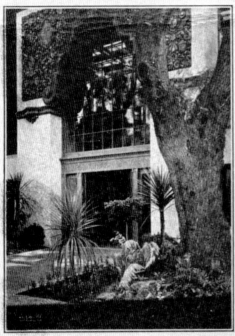

Hollywood Chamber of Commerce Building

A TRIP THROUGH THE MOTION PICTURE STUDIOS. Studio tours were very popular in the 1920s, and this advertisement was helpful to tourists trying to satisfy their curiosity about moviemaking in Hollywood. This building was completed in 1926 for the Hollywood Chamber of Commerce at Sunset Boulevard and Hudson Avenue. The organization stayed in this building for 50 years. This structure memorializes Hollywood's past. (Published by the Hollywood Chamber of Commerce.)

POSTCARD HISTORY SERIES

Hollywood Studios

Tommy Dangcil

ARCADIA
PUBLISHING

Published by Arcadia Publishing
Charleston SC, Chicago IL, Portsmouth NH, San Francisco CA

Printed in the United States of America

Library of Congress Catalog Card Number: 2006933254

For all general information contact Arcadia Publishing at:
Telephone 843-853-2070
Fax 843-853-0044
E-mail sales@arcadiapublishing.com
For customer service and orders:
Toll-Free 1-888-313-2665

Visit us on the Internet at www.arcadiapublishing.com

ON THE FRONT COVER: Warner Brothers contract actress Patricia Ellis is featured on the set of *Freshman Love* (1936), in which she costarred with Warren Hull and Frank McHugh.

ON THE BACK COVER: Pictured is Christie Studios, the first movie studio in Hollywood and now home to KCBS TV. (Published by Grogan Photo System Inc.)

CONTENTS

For my daughter Jessica Rose
My constant reminder of Truth, Love, and Happiness . . .

INTRODUCTION

Close your eyes and imagine yourself in America 100 years ago looking through a peephole at the nickelodeon or watching "the flickers" in a small room filled with strangers all amazed by the lights and shadows. In the early 1900s, motion pictures were still a novelty, but cinema immediately captivated audiences by suspending disbelief, if for only a reel or two. Back then, films weren't the feature length they are today, and the quality and sound were not presented in THX surround sound or shot on Panavision cameras, but filmmakers knew that a new medium had arrived. Everything filmmakers were doing for the progress of cinema was revolutionary, and this new art form soon took on new meaning as an important visual communication device for the world.

There are many stories about how the "Hollywood studios" ended up geographically in Hollywood, California, but the story of the film crew that hopped off a train when it stopped and quickly began shooting because of the great sunlight is legendary. These filmmakers realized that it wasn't only that day that the sun came out, but the next day, and the day after that, and for most of the year. Imagine coming from an East Coast climate and making movies and then making the transition to filming on the West Coast, where the sun was out and you could film on the beach while all the "suits" that were funding you were over 3,000 miles away. This distance also laid the foundation for the Us (West Coast filmmaker "artists") versus Them (East Coast moneymaker "Suits") mentality in the motion picture industry.

In 1908, a legal monopoly called "The Trust" was organized and headed by the Edison Film Manufacturing Company. This group pooled all of their assets and demanded licensing fees from all producers, distributors, and exhibitors. Without the access of film, cameras, and movie theaters for distribution, the Trust created the first motion picture "Independents." These Independents were some of the first filmmakers to make the move to California to get away from the strong-arming subsidiary of the Trust called the General Film Company. Moving to the West Coast also proved to be serendipitous because these filmmakers could enjoy the year-round sunshine, which proved to be optimal for location shooting before the use of formal motion picture lighting.

In October 1911, a small building with a large lot in the back named Blondeau's Tavern became the first motion picture studio in Hollywood. It was located on the northwest corner of Sunset Boulevard and Gower Street. This tavern became Christie Studios and eventually Carl Laemmle's Universal Film Manufacturing Company. By 1915, Universal left the Sunset Gower lot and opened Universal City in the San Fernando Valley. Christie Comedies stayed on the lot until 1928, the year they moved to Studio City with Mack Sennett. Across the street from Christie Studios, on the southwest corner, was Century LKO Studios, which had its own back lot. On the southeast corner of Sunset Boulevard and Gower Street, several studios popped up and spread to Gordon Street to the east and Fountain Avenue to the south. This strip of movie studios became what is known as "Poverty Row." After all the studios came and went, Columbia Pictures formed under the hand of Harry Cohn in 1924. This intersection became an epicenter for studios and filmmakers from all

over the world. Hollywood had become the nucleus for cinema. Artists and production technicians had moved into every Hollywood neighborhood and called this sleepy little Southern California suburb of Los Angeles home.

Over the years, many Hollywood studios have come and gone. Some of them remain today, and many only lasted for a few weeks during the second decade of the 20th century. The one thing that remains constant is the Hollywood studio mind-set. Hollywood is not only a geographical place on the map of the world, but an idea and frame of mind. There is something that happens in a Hollywood studio that evokes brilliance, serendipity, and nostalgia all at once. It's been a magic carpet ride for me, and I've been working in this town and all over the world for the last 17 years. No other place has as much talent and as many technicians dedicated to the entertainment industry as Hollywood. It is here that film, television, and radio studios thrive at the highest level of expertise. There isn't another place on earth with as many studios for radio, television, and film concentrated in one place as Hollywood and Los Angeles County.

The precise year of the first movie set in Los Angeles has been in question for decades, but many believe that it was in Downtown Los Angeles in 1908 behind a Chinese laundry shop for Selig Polyscope. The movie studios in the San Fernando Valley and Culver City aren't physically in the city of Hollywood. As stated earlier, Hollywood isn't just a place, it's anywhere where a high standard is represented; therefore, the movie studios in those areas are indeed Hollywood studios through and through. There is a filmmaking term lighting technicians and grips use to describe the act of hand-holding something while the camera is moving: to "Hollywood" something. It means to use finesse and try to obtain seamless perfection. If a line of rope is dropped out of the "perms" (permanent grid on a motion picture stage) or "greenbeds" (temporary catwalk on a motion picture stage) and the technician on the floor has tied something on it to be pulled up and it is ready to be pulled up, then the technician would say "Hollywood," which means it's ready—haul it up. The word has come to mean many things, but at a Hollywood studio, it signifies that it's ready to be pulled up. Possibly the term came to be because to "Hollywood" something means it has to be ready, as if everything Hollywood is polished and finished.

How many people can say that they have walked on the same soundstages where Humphrey Bogart, Cary Grant, James Cagney, Spencer Tracy, Rita Hayworth, Linda Darnell, Gail Russell, Veronica Lake, and Gene Tierney worked? When I go to work, I step into a land of make-believe. These far-off lands are named Warner Brothers, Universal, Metro-Goldwyn-Mayer, 20th Century-Fox, and Paramount, just to mention a few. The moguls that put the coal in these factories roll off my tongue quickly: Carl Laemmle, Irving Thalberg, Louis B. Mayer, William Fox, Jack Warner, Harry Cohn, David O. Selznick, Darryl F. Zanuck, Adolph Zukor, Jesse Lasky, and countless others.

The same thing could be said for television and radio studios where countless hours of programming were created in studios that were at one point a few blocks away from each other in the 1930s. ABC was located on Vine Street, and one block south was NBC on Sunset Boulevard. CBS was built on the site of Hollywood's first motion picture studio on Sunset Boulevard. KFWB was located up the street from CBS on El Centro and Yucca. KMTR was located near Paramount on Melrose Avenue but then moved to Cahuenga Boulevard. KHJ-TV was located on Vine Street and Fountain Avenue in the 1950s, and all of these studios were practically within walking distance to each other.

In the last few years, there have been two major movie studios built in Los Angeles: the Los Angeles Center Studios in Downtown Los Angeles and the Raleigh Studios of Manhattan Beach. These stages represent more studio space to produce motion pictures in Hollywood and, more importantly, California. Hopefully they will help prevent "runaway" productions from shooting in tax-incentive states like Arizona, Texas, and Louisiana. Perhaps new laws and legislation will assist Hollywood with making California a tax-incentive state to keep motion picture production here in this fine state, which has contributed to over a century of cinema's finest work. For the last decade, the phrase "Keep Hollywood Home" has become familiar to artists, filmmakers, and studio technicians in Los Angeles trying to work close to where they live, which happens to be near all the movie studios.

One

IN THE BEGINNING

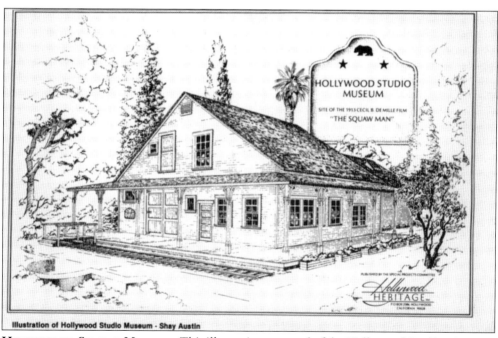

Illustration of Hollywood Studio Museum - Shay Austin

HOLLYWOOD STUDIO MUSEUM. This illustration postcard of the Hollywood Studio Museum, which still exists as the Hollywood Heritage Museum on Highland Avenue, is by artist Shay Austin. In 1913, this building was used to film *The Squaw Man*, Hollywood's first feature-length motion picture. The building is also Registered Landmark No. 554 by the California State Parks Commission and the Landmarks Committee of Los Angeles County. (Published by Hollywood Heritage.)

MACK SENNETT STUDIOS. An early view of Mack Sennett Studios in Edendale, now Silver Lake, looks north. In 1912, Sennett created the Keystone Company, and by the early 1920s, the studio covered 28 acres and both sides of Allesandro Avenue, now Glendale Boulevard. This is where the famous Keystone Kops were created and the comedic geniuses of Charlie Chaplin, Harold Lloyd, and Charley Chase were born. On November 5, 1982, the City of Los Angeles declared these studios Historic Cultural Monument No. 256.

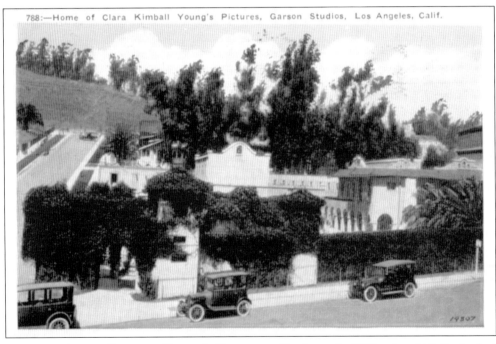

HOME OF CLARA KIMBALL YOUNG'S PICTURES. By the early 1920s, the old Selig lot had served several companies. After William Fox left Clara Kimball Young's, Garson Studios were born in this Mission-style movie studio built in 1910. This postcard was mailed in 1924, when Young was using the studio to produce her films. The stages and production offices were demolished in the 1930s. (Published by M. Kashower.)

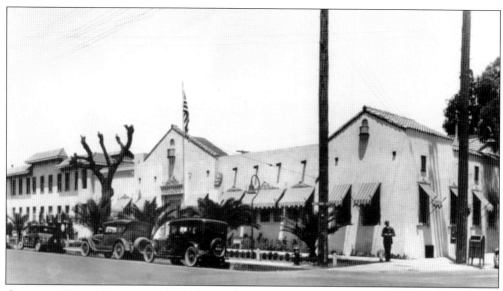

CHRISTIE FILM COMPANY. This is an advertising postcard featuring Christie Studios for Pittsburgh Proof Products, declaring it Testimonial Photograph No. 27. Pittsburgh Proof Products were used to make all the sets and permanent buildings surrounding the studio located at Sunset Boulevard and Gower Street. This was the location of the first motion picture studio in Hollywood, dating to October 1911, for the Nestor Film Company. (Published by Grogan Photo System Inc.)

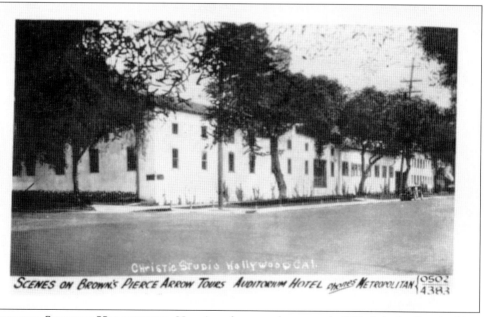

CHRISTIE STUDIOS HOLLYWOOD. Here is a photograph postcard of Christie Studios, looking east on Sunset Boulevard from El Centro Avenue. Tours of Hollywood have been going on since the beginning of the 20th century, and this advertisement touts Brown's Pierce Arrow Tours from the Auditorium Hotel in the early 1920s. The location was originally the site of Blondeau's Tavern and was converted to a motion picture studio by William Horsely and Al Christie.

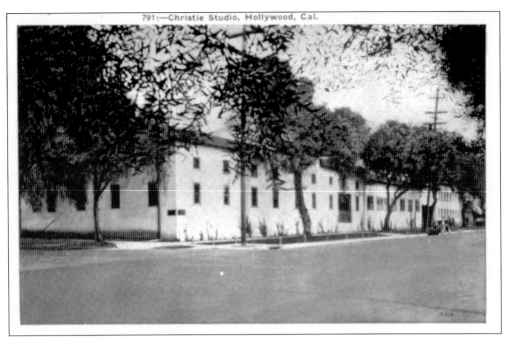

791:—Christie Studio, Hollywood, Cal.

MORE CHRISTIE STUDIOS. This white-bordered postcard was made from a real photograph and shows Christie Studios in the early 1920s. Al Christie took over the studio in 1916 and produced Christie Comedies here until 1928. The studio was torn down in 1937, and in 1938, CBS and KNX News Radio began broadcasting at the site. (Published by M. Kashower.)

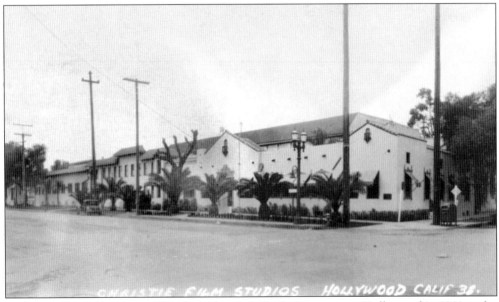

CENTAUR FILM COMPANY. David Horsley and Al Christie came to Hollywood in 1911 under the flag of the Centaur Film Company, and it was in this studio that they created the Nestor Film Company. In 1912, the Universal Film Manufacturing Company took over the lot. In 1915, Universal moved into its new facility, but Christie remained on the lot for the next 13 years. Seen in this photograph postcard is the newly installed streetlight in front of the studio on Sunset Boulevard.

12

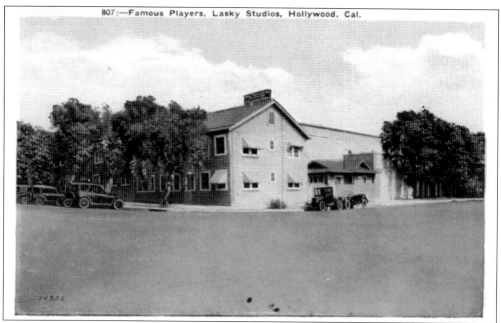

FAMOUS PLAYERS, LASKY STUDIOS. The origins of Paramount can be traced to Lasky Studios, which were located on Selma Avenue and Vine Street. This location, owned by Jacob Stern, originally was a horse barn. It was converted to a production facility in 1912 by Harry Revier and L. L. Burns. In 1913, they enlarged the existing open-air stage to 40 feet by 70 feet and improved the silk and muslin overhead diffusers to "modernize" the facility. By the time Jesse Lasky and Cecil B. DeMille leased the studio in 1913, a second stage was built, and the existing dressing rooms and ceiling were expanded and ready for filming the production of *The Squaw Man.* (Published by M. Kashower.)

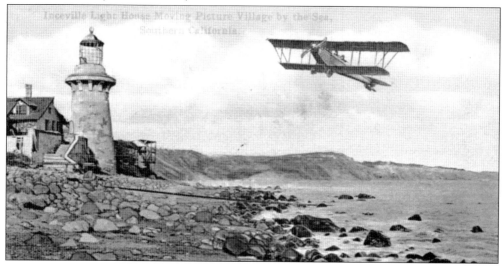

INCEVILLE LIGHT HOUSE MOVING PICTURE VILLAGE BY THE SEA. Thomas Ince built "Inceville" in 1912 on the western end of Sunset Boulevard, at Pacific Coast Highway on the Santa Monica Bay seashore. Inceville was nestled in the canyon and served as Ince's production facility for several years. This postcard shows a lighthouse and exterior sets and buildings around 1910. (Published by M. Kashower.)

E & R JUNGLE FILM COMPANY. The E & R Jungle Film Company, formed in 1914, was owned by J. S. Edwards, John Rounan, E. E. Rounan, Harry Edwards, and T. H. Glaze. In 1918, the E & R Jungle facility, located on Soto Street, was used to film scenes in *Tarzan of the Apes* because the back lot had a decent jungle set. E & R was most successful with their serials featuring the chimpanzees Sally and Napoleon.

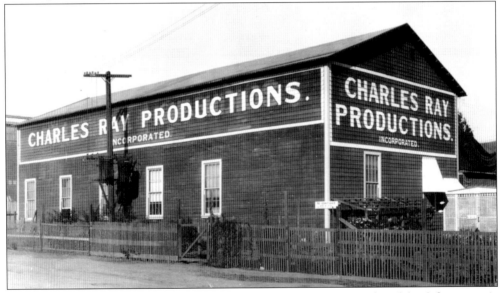

CHARLES RAY PRODUCTIONS. In 1912, the Lubin Company purchased land for a movie studio on Fleming Street off of Sunset Boulevard in Hollywood. Charles Ray took over the studio in the early 1920s after Essanay, Kalem, and Jesse Hampton came and went. It was Ray who built the first "sound stage" on the lot, which included a glass roof and installation of electrical power for motion picture lighting. The lot has changed hands as the Monogram, Allied Artists, and ColorVision studios but has been KCET-TV for over 35 years.

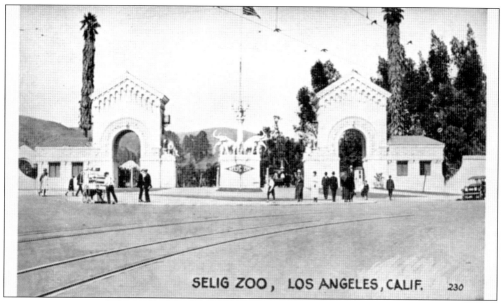

SELIG ZOO, LOS ANGELES, CALIF. 230

WIDE ANGLE ON THE SELIG ZOO. This is a wide-angle postcard view of the Selig Zoo front entrance in the early 1920s. The zoo, located in Lincoln Park at 3800 Mission Road, was situated on a 32-acre lot. It was completed at a cost of $1 million in 1915. Louis B. Mayer leased space on the lot up until the merger that resulted in Metro-Goldwyn-Mayer. (Published by Pacific Novelty Company.)

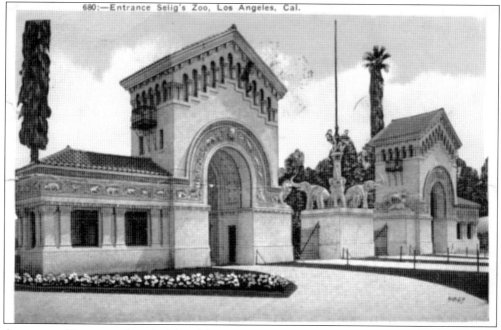

680:—Entrance Selig's Zoo, Los Angeles, Cal.

ANOTHER VIEW OF SELIG'S ZOO ENTRANCE. Two grand arches, which cost $60,000 to construct, welcomed visitors to the entrance, seen in this postcard mailed in 1924. Even though the Selig Company folded in 1917, the zoo remained in operation until 1923, when it closed after a powerful rainstorm destroyed most of the park. The animals were donated to the city and moved to Griffith Park, a forerunner to the Los Angeles Zoo. (Published by M. Kashower.)

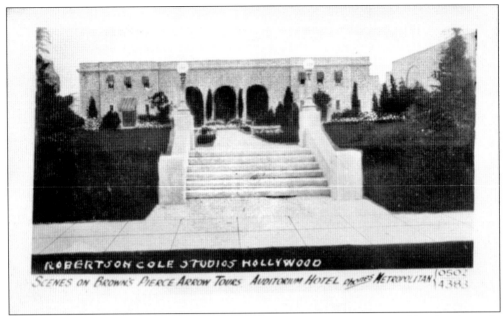

ROBERTSON COLE STUDIOS IN HOLLYWOOD. Robertson Cole began as a film distributor in 1919. By 1920, a 13.5-acre lot was acquired by the company for production in the Colegrove District of Hollywood, on Gower Street. The construction of this studio was completed two years later and included production offices and three stages. In 1922, Robertson Cole became the Film Booking Offices (FBO), and Joseph Kennedy was on the board of directors. This lot now consumes the west end of Paramount Studios, from the cemetery on the north to Melrose Avenue on the south.

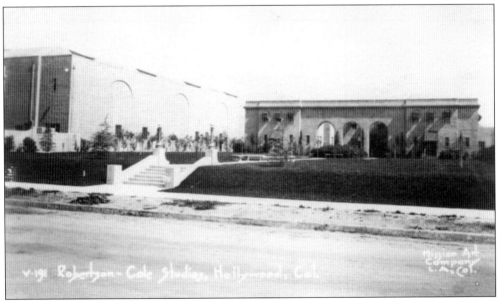

ROBERTSON COLE STUDIOS VIEW. Here is a photograph postcard of the Robertson Cole Studios looking northeast from Gower Street. This portion of the lot became RKO in 1928. (Published by Mission Art Company.)

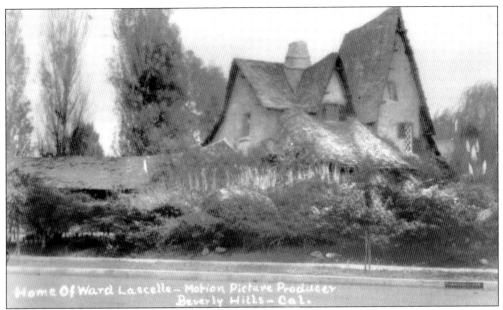

HOME OF WARD LASCELLE. This residential home in Beverly Hills was originally constructed for the Willat Studios in Culver City; Irvin Willat was a production designer in the second decade of the 1900s and incorporated this building for his movie studio. It served as a production office until it was moved here in the 1920s. Ward Lascelle was a movie producer in the 1920s.

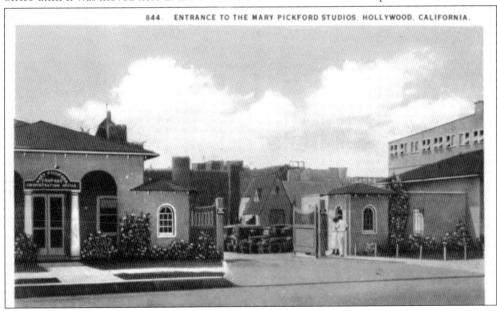

ENTRANCE TO THE MARY PICKFORD STUDIOS. This studio on Formosa Avenue began as the Jesse Hampton Studios in 1919. Mary Pickford and Douglas Fairbanks took over the 11-acre lot in 1922. This studio was renamed United Artists soon after the company was formed by Pickford, Fairbanks, D. W. Griffith, and Charlie Chaplin. On April 21, 1955, Sam Goldwyn officially renamed this lot the Goldwyn Studios. Warner Brothers took over the lot in 1980 and called the studio Warner Hollywood until 2000. (Published by Western Publishing and Novelty Company.)

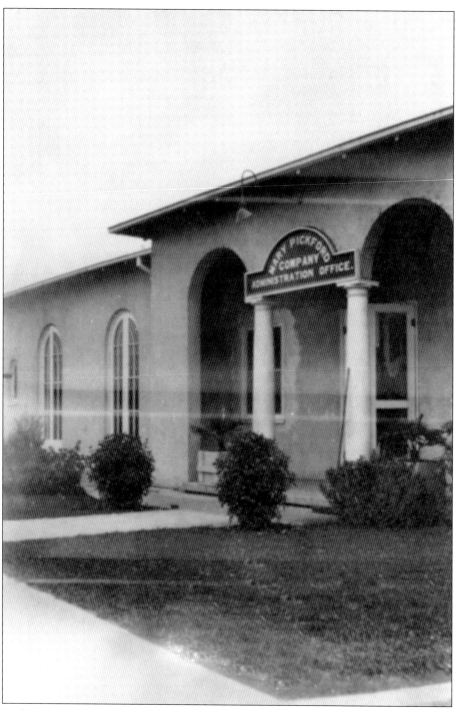

MARY PICKFORD COMPANY. This is a view of the administration office of the Mary Pickford Company, looking southwest on Formosa Avenue in the early 1920s. Some of Hollywood's biggest sets in the silent era were built here, for *Robin Hood*, *The Thief of Bagdad*, and *The Black Pirate*. Sam Goldwyn later produced such sound classics as *The Hurricane* and *Wuthering Heights* here. Today the studio has seven stages and continues to emote old Hollywood charm.

Two

UNIVERSAL

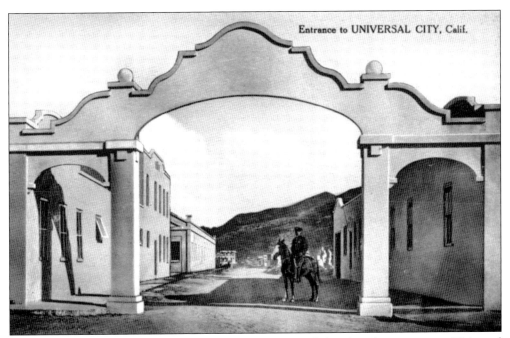

ENTRANCE TO UNIVERSAL CITY. Here is a rare postcard showing the entrance to Universal City. A Universal police officer mounted on horseback patrols the newly built studio on Laemmle Boulevard in the San Fernando Valley. (Published by Fred Harvey.)

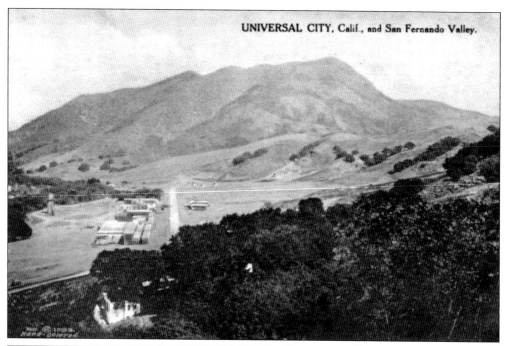

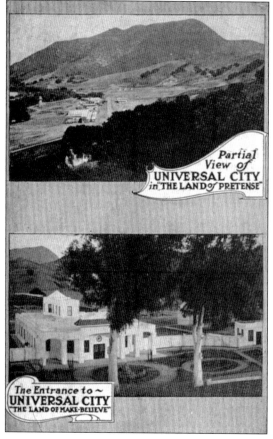

UNIVERSAL CITY AND SAN FERNANDO VALLEY. In this hand-colored postcard, one can see the beginning of Universal City's back lot in 1915. Today the long road is the main pathway for trams on the Universal Studios Tour as they head to the stages and back lot of Universal City. (Published by Fred Harvey.)

PARTIAL VIEW AND ENTRANCE TO UNIVERSAL CITY. On March 15, 1915, the Universal City gates opened for the first time. This card, mailed on March 3 of that year, is an invitation to come visit Universal and bring a friend. By 1930, Universal had 16 stages and 60 buildings on 365 acres. (Published by the Universal Film Manufacturing Company.)

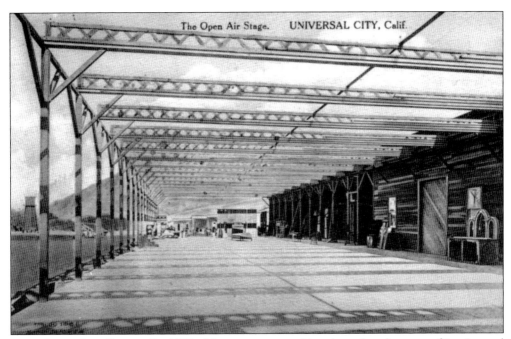

The Open Air Stage. UNIVERSAL CITY, Calif.

THE OPEN-AIR STAGE. In 1915, this stage was considered modern because of its size and overhead rigging. Because sound was not an issue at this time, several companies could film simultaneously and not be a burden to each other. (Published by Fred Harvey.)

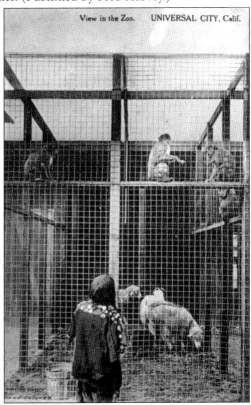

View in the Zoo. UNIVERSAL CITY, Calif.

VIEW IN THE ZOO. Universal City was equipped with everything needed to produce a motion picture, including animals used for filming, which came from the studio's zoo, located in the original section of the back lot. (Published by Fred Harvey.)

21

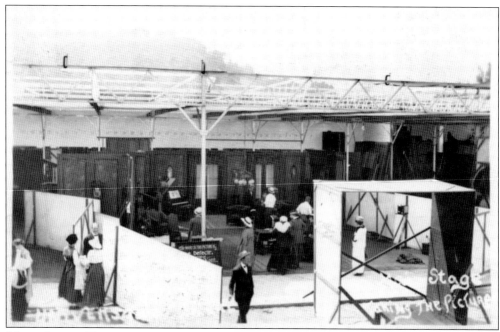

MAIN STAGE, TAKING THE PICTURE. Leon Kent directed *The Deficit* on the main stage in Universal City; here it is being filmed at the studio in 1915. The film, released in October 1915, starred Hobart Henley and Agnes Vernon.

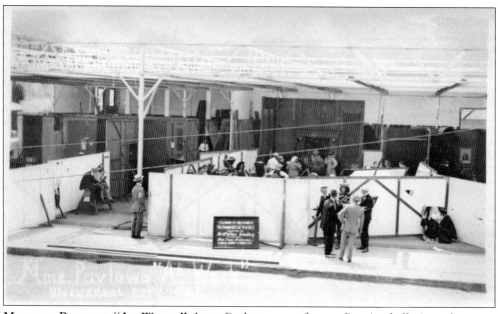

MADAME PAVLOVA "AT WORK." Anna Pavlova was a famous Russian ballerina who came to Universal City to film *The Dumb Girl of Portici*, which was released in 1916. Phillip Smalley directed the film, and it was a costly production. Here is a great postcard showing the extras surrounding the set.

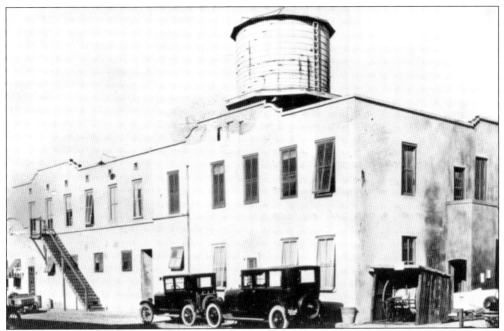

BULL PEN. Universal City was the first city created entirely for motion picture production. When he designed the city, Carl Laemmle thought of just about everything that would assist in making films on the lot without outside help. Here is a view of the Bull Pen building and dressing rooms where actors and extras would go to get into wardrobe before coming to the set.

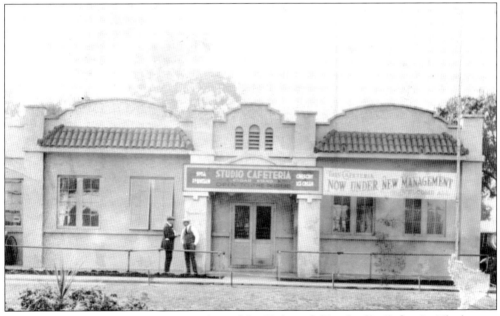

STUDIO CAFETERIA. Here is a great view of the Universal City Studio Cafeteria. The banner reads, "Now Under New Management." All of the studios would eventually have cafeterias or commissaries for their casts and crews. Also at this Universal City cafeteria, cigars, soda, ice cream, and other items could be purchased.

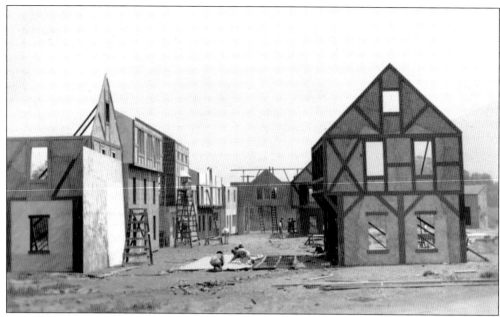

ENGLISH STREET ON ENORMOUS LOT. Universal City had the biggest back lot in Hollywood. At the time this photograph postcard was made, the studio was creating sets left and right for films. Here a dozen laborers, carpenters, and gang bosses are seen physically building the sets.

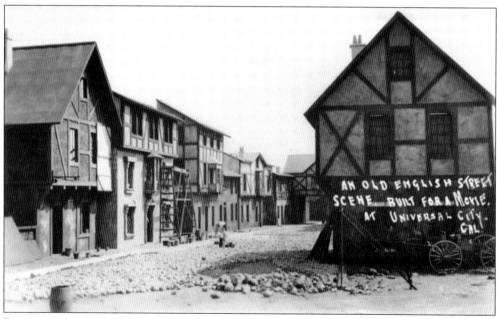

BUILDING AN OLD ENGLISH STREET. Above is a rare look at an old English street after more work has been done (than in the previous photograph). Cobblestones have been added to the street, and the facades of the buildings are more elaborate.

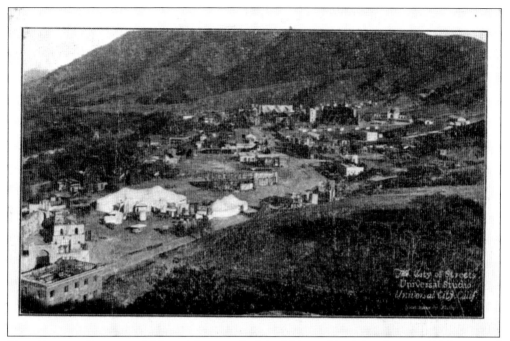

THE CITY OF STREETS. This aerial postcard of the Universal back lot shows multiple sets and buildings in different scenes.

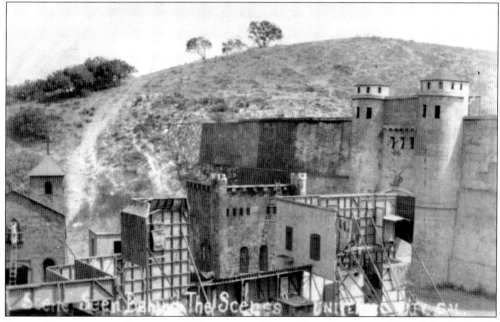

SCENE BEHIND THE SCENES AT UNIVERSAL CITY. Here is a great view of the back side of the sets' facades on the back lot. These sets do not have platforms and catwalks like today because they were mostly made for day exteriors in early filmmaking. In 2007, Universal's back lot has access to water, air, gas, and AC and DC power. The back of this card is dated September 14, 1915.

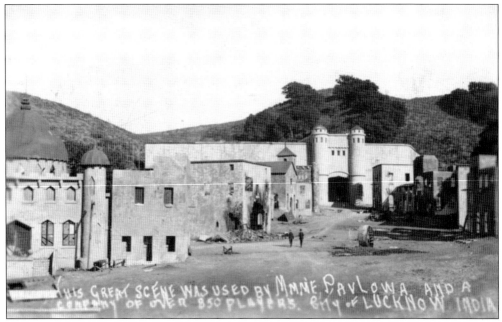

LOIS WEBER FILM. *The Dumb Girl of Portici* was a costly production for Universal, as the company provided parking, wardrobe, food, and, of course, salaries for the 850 extras on the film, which was directed by the Lois Weber Company with Phillip Smalley This completed set, representing Luckno, West India, was used by Anna Pavlova and the company of over 850 players.

EXTRAS HOLDING. Background extras are seen in this card postmarked October 17, 1915. The back of this card reads: "This will interest you. This is a picture of a part of the largest open-air stage in the world at Universal City where movie films are made. C." Universal was the first studio to have a formal tour, and it still has the best motion picture studio tour in the world.

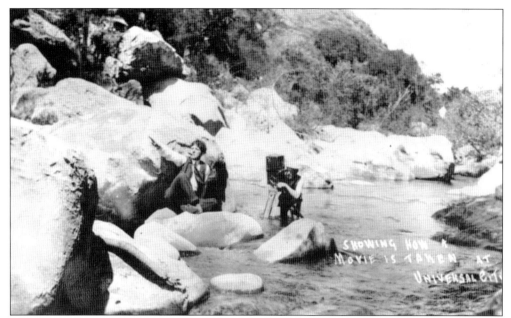

SHOWING HOW A MOVIE IS MADE. A director and cameraman are seen at Universal City in this *c.* 1915 postcard. As primitive as this looks, it all comes down to the basics, which are a camera and a vision. The director of photography can shoot anything, but it takes an idea from a script to transform those written words to film.

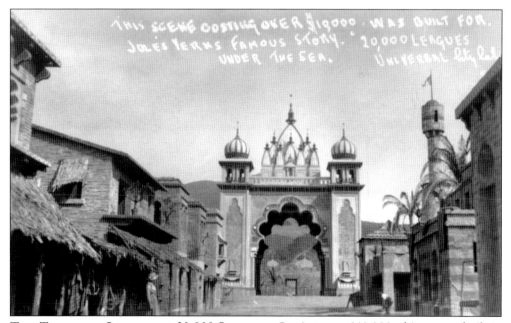

TEN THOUSAND LARGE FOR 20,000 LEAGUES. Costing over $10,000, this set was built in Universal City, California, for Jules Vern's famous story *20,000 Leagues Under the Sea*, which was released in 1916. The movie was said to have cost over $200,000 to produce. Also notable in this film was the use of underwater photography.

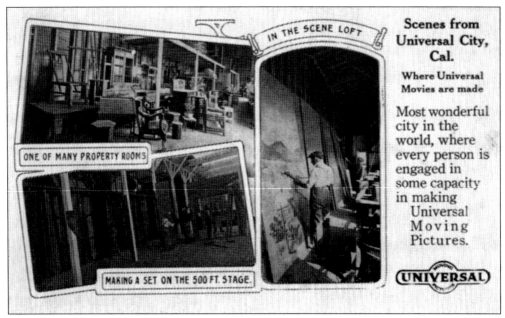

SCENES FROM UNIVERSAL CITY. Universal was the first studio to produce their own postcards. These three views show one of the many property rooms, the scene loft, and the making of a set on the 500-foot stage. This card reveals several of the steps in making a motion picture, and all of this took place on the Universal lot without outside support.

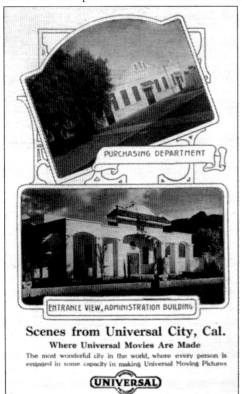

MORE SCENES FROM UNIVERSAL CITY. These two scenes show the purchasing department and the entrance to the administration building—two important places on the Universal lot and the nuts and bolts of any film. Film production begins with prep and paperwork.

STILL MORE SCENES FROM UNIVERSAL CITY. One of the restaurants can be seen in this card as well as the Universal City Hospital operating room. Imagine being injured in 1915 and not having a hospital for several miles. Luckily Universal City was created to be self-sufficient and was ahead of its time.

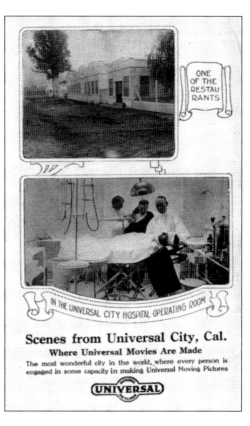

Scenes from Universal City, Cal.
Where Universal Movies Are Made
The most wonderful city in the world, where every person is engaged in some capacity in making Universal Moving Pictures

UNIVERSAL

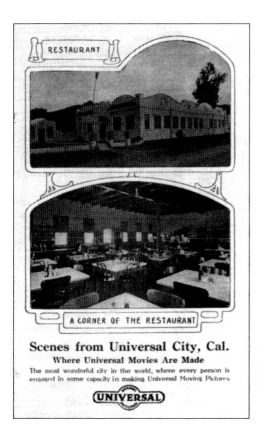

Scenes from Universal City, Cal.
Where Universal Movies Are Made
The most wonderful city in the world, where every person is engaged in some capacity in making Universal Moving Pictures

UNIVERSAL

ANOTHER RESTAURANT. These two views show another restaurant on the Universal lot. Today's lot has a main commissary with posters of movies dating back to 1915 on the walls. There is also a breakfast and lunch café adjacent to Stage 28.

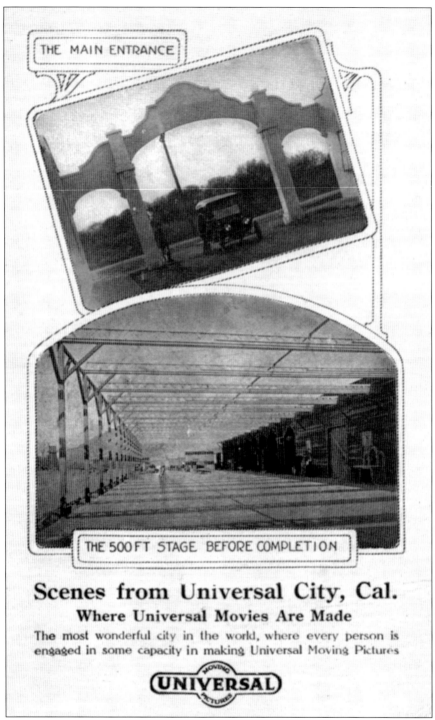

THE MAIN ENTRANCE

THE 500 FT STAGE BEFORE COMPLETION

Scenes from Universal City, Cal.

Where Universal Movies Are Made

The most wonderful city in the world, where every person is engaged in some capacity in making Universal Moving Pictures

UNIVERSAL

IMPRESSIVE SET. The main entrance and the 500-foot stage before completion are two of the most important views of this set. In 1915, it was quite impressive to come to Universal City, which was created entirely for the production of motion pictures, and see beautiful architecture for an entrance and walk onto the largest stage in the world.

A CHARACTERISTIC GLIMPSE

AN ENTRANCE ON THE BOULEVARD

Scenes from Universal City, Cal.
Where Universal Movies Are Made
The most wonderful city in the world, where every person is engaged in some capacity in making Universal Moving Pictures

UNIVERSAL

THE ROADS TO SHOW BUSINESS. A view of the road to the back lot can be seen in the upper image of this card. The bottom image is one of the entrances located on Laemmle Boulevard (now Lankershim Boulevard) in 1915.

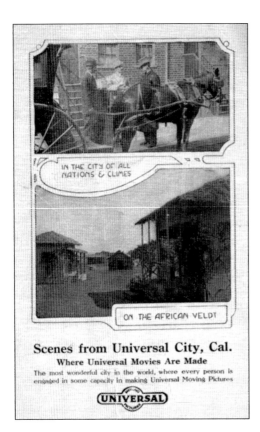

Scenes from Universal City, Cal.

ANY NATION, ANYTIME. In the back lot at Universal, any country can be re-created with a little imagination. On the African veldt or in the city of all nations and climates on a nondescript street, Universal continues to be a place of suspended disbelief and fantasy.

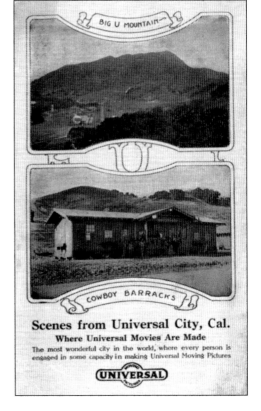

Scenes from Universal City, Cal.

COWBOYS BARRACKS. The Big U Mountain still is the backdrop for Universal's back lot. Horse wranglers and cowboys in motion pictures lived in the Cowboy Barracks, which was conveniently located in the back lot.

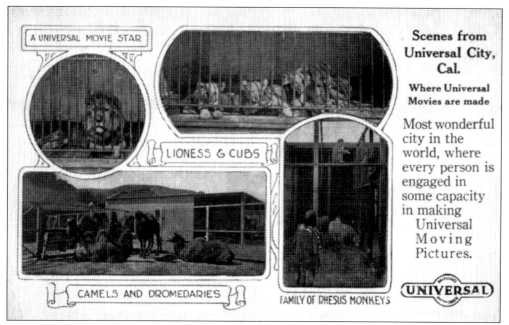

ZOO DENIZENS. When Universal City opened in 1915, filmmakers could select animals from a complete zoo to use in filming. These scenes show a Universal star, lioness and cubs, camels and dromedaries, and a family of rhesus monkeys.

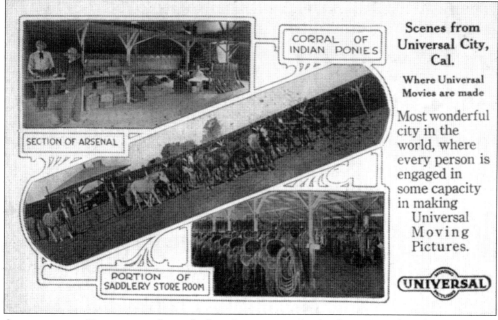

ARSENAL AND EQUIPMENT. Instead of renting props and animals, Universal stocked an arsenal to use in filming cowboy and military films. Here a portion of the weapons that were stored can be seen. Equally important is the saddlery storeroom pictured in the bottom scene.

LIONS AND BEARS AND . . . The zoo would not be complete without a bear pit, some bear cubs, and wild birdcages, which must have taken up a lot of space. In the bottom scene, a lion cage can be seen with overhead protection—escaping was not an issue.

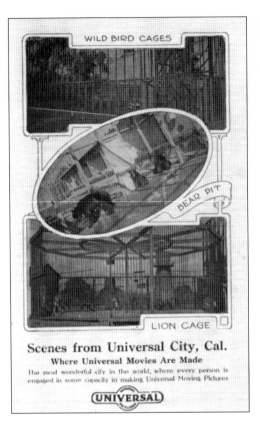

ALL THE UNIVERSALS. This card, mailed on December 12, 1915, shows a village in the back lot and a scene with soldiers in a foreign land.

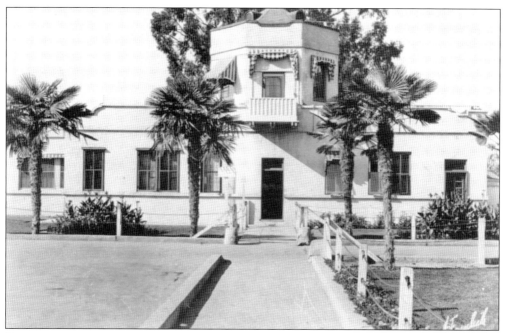

PRODUCTION BUILDING IN UNIVERSAL CITY. Here is a view of a production building from the back of Laemmle Boulevard in the early 1920s. On the back of this postcard, it reads: "Have just seen Universal City, the greatest Motion Picture Colony and strangest city in the World. Be sure to see their Pictures."

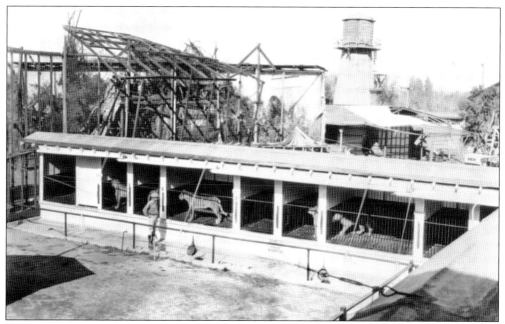

UNIVERSAL CITY ZOO. In this photograph card, an employee stands near the lion cages at the zoo. The metal railing in the foreground exists to keep the visitors from getting too close. Behind the lions are the wild bird cages with wire mesh wrapped around the beams of the cage.

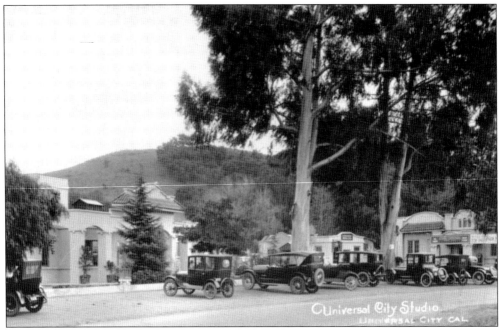

PARKING LOT AND CAFETERIA. Laemmle Boulevard got a bit crowded with employee parking outside the main entrance to the lot. The studio cafeteria is in the bottom right of the photograph, and the post office is in the middle.

UNIVERSAL STUDIOS ENTRANCE. Here is the Laemmle Boulevard entrance to Universal Studios from this written on but not mailed card from August 1, 1934. The early-1920s Universal logo is above the two doors of the building in the center of the postcard.

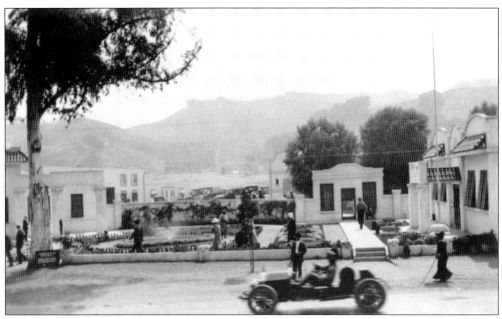

LARGEST MOVING PICTURE STUDIO IN THE WORLD. This view of the studio, looking west, shows the flower garden in front of the Laemmle Boulevard entrance shortly before 1920. Production buildings can be seen on the left side of the card.

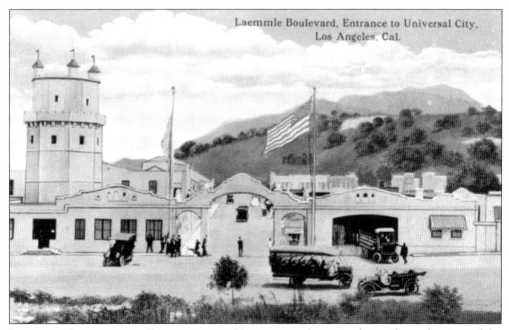

LAEMMLE BOULEVARD: ENTRANCE TO UNIVERSAL CITY. In this wide-angle view of the front entrance, an early tour bus is visible at the bottom of the postcard. Admission to the Universal Tour was 25¢ and included a tour of the studio and back lot. Visitors also had the chance to watch a motion picture being filmed.

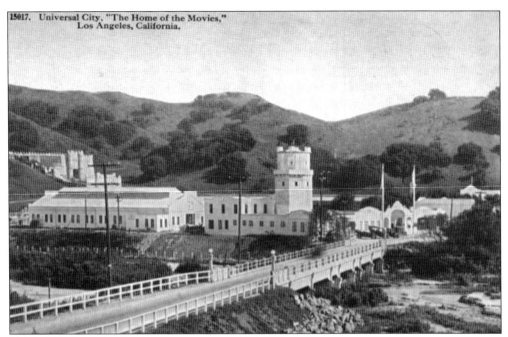

"THE HOME OF THE MOVIES." The Los Angeles River winds its way towards the main entrance of Universal City in this card from just before 1920. A portion of the back lot is visible in the left center of the image. (Published by Pacific Novelty Company.)

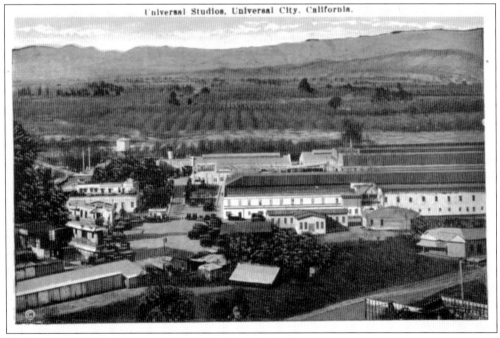

TWO HUNDRED ACRES OF PRODUCTIONS. San Fernando dominates the background in this view looking north from the Universal lot in the early 1920s. At this time, the lot consumed 200 acres and was a full-force movie factory. (Published by California Postcard Company.)

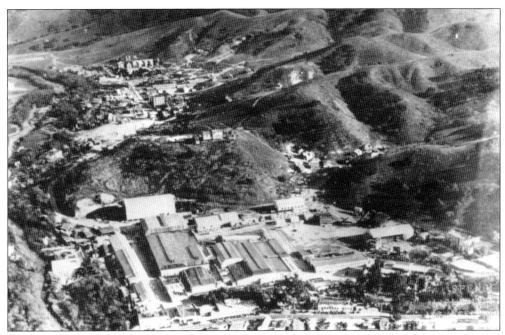

VIEW OF UNIVERSAL CITY FROM THE AIR. In this aerial view of Universal City, the stages and production buildings as well as the back lot towards Big U Mountain are visible. This image shows the magnitude of the lot and why it is called a city. (Published by Spence.)

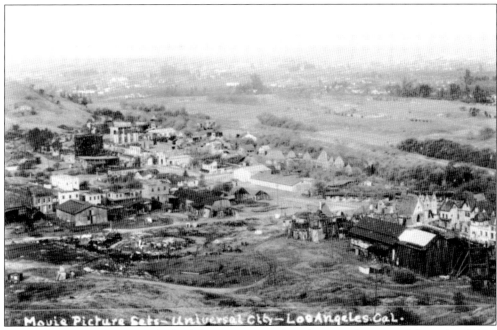

MOVING PICTURE SETS. The back lot, as seen in this photograph postcard from the 1930s, was full of sets being erected, shot, and torn down. Sound recording was now a factor to deal with in filming, and companies could not shoot side-by-side anymore.

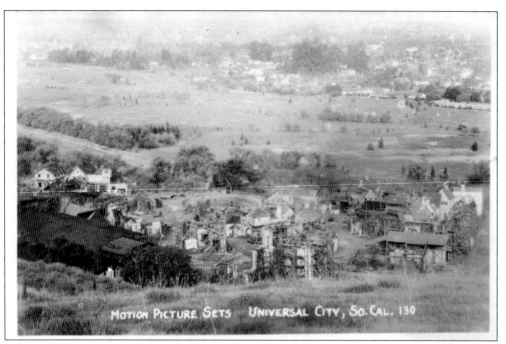

MOTION PICTURE TOWN. This high-angle view of the Universal back lot from the mid-1930s, looking northwest towards the stages, shows an entire village (or town) being built with buildings and facades.

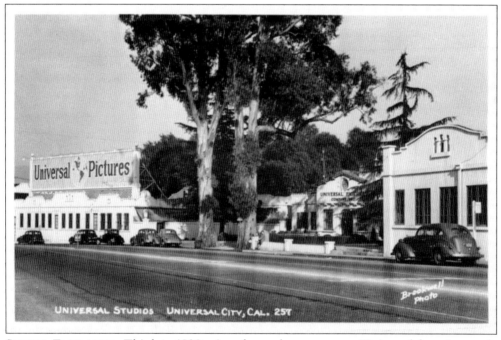

STUDIO ENTRANCE. This late-1930s view shows the entrance to Universal from Laemmle Boulevard. Note all the employee cars parked along the boulevard. (Published by Brookwell Photo.)

Three

METRO-GOLDWYN-MAYER

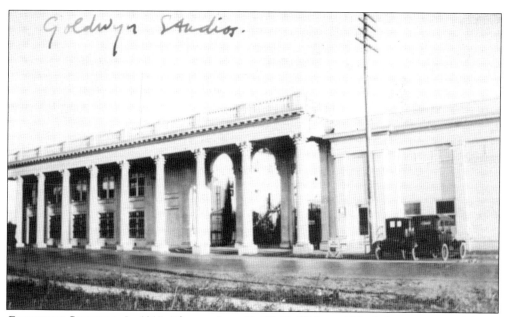

GOLDWYN STUDIOS. In 1915, Thomas Ince, D. W. Griffith, and Mack Sennett merged forces and opened Triangle Studios in Culver City. By 1918, Triangle Studios were not very prolific, and Sam Goldwyn took over the studio. This view shows the colonnade on Washington Boulevard in 1919.

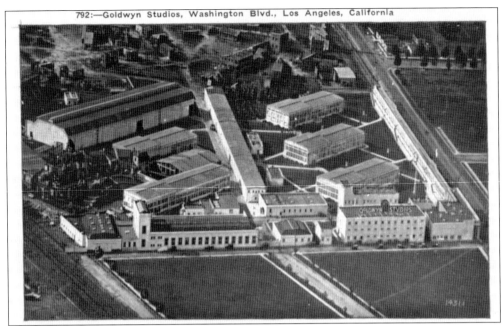

SAM GOLDFISH'S EMPIRE. Sam Goldfish began the Goldwyn Pictures Corporation on November 19, 1916. By 1922, Goldwyn Pictures had been taken over by Marcus Loew. In this aerial view of the Goldwyn Studio, glass stages can be seen on the right-hand side of the card. The long strip of stages on the left-hand side of the card remain as stages 18, 19, and 20. (Published by M. Kashower.)

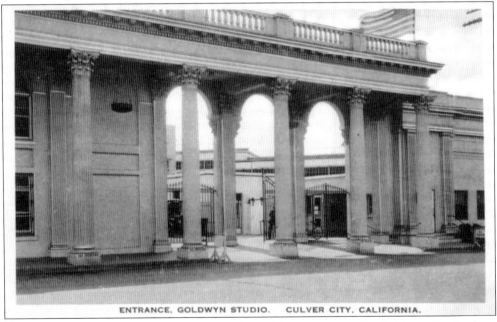

ENTRANCE, GOLDWYN STUDIO. CULVER CITY, CALIFORNIA.

ENTRANCE, GOLDWYN STUDIO. Here is a view of the entrance to the Goldwyn Studio from the early 1920s. With the merger of Metro Pictures, the Goldwyn Pictures Company, and Louis B. Mayer, MGM was born and contributed to some of the finest films ever produced from the Hollywood Studio System. (Published by the Albertype Company.)

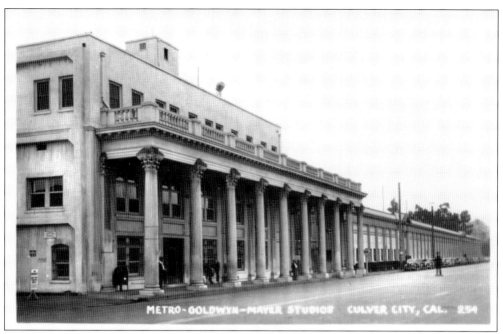

METRO-GOLDWYN-MAYER STUDIOS. On April 26, 1924, this studio was now known as Metro-Goldwyn-Mayer, the names of the three merged companies. Louis B. Mayer would run the studio, and a young Irving Thalberg was appointed head of production. This is a view looking west on Washington Boulevard with cars parked on the street in front of the colonnade.

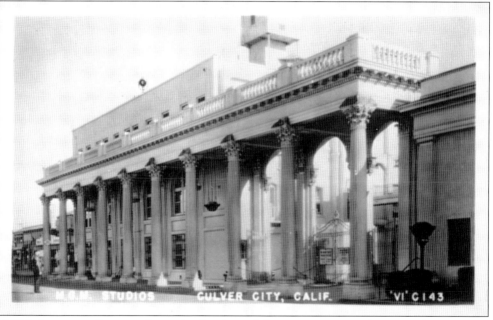

MGM STUDIOS, CULVER CITY. At the time of the MGM merger, the studio had six large glass-enclosed stages, laboratories, dressing rooms, bungalows, shops, storage buildings, and exterior sets all situated on a 40-acre lot.

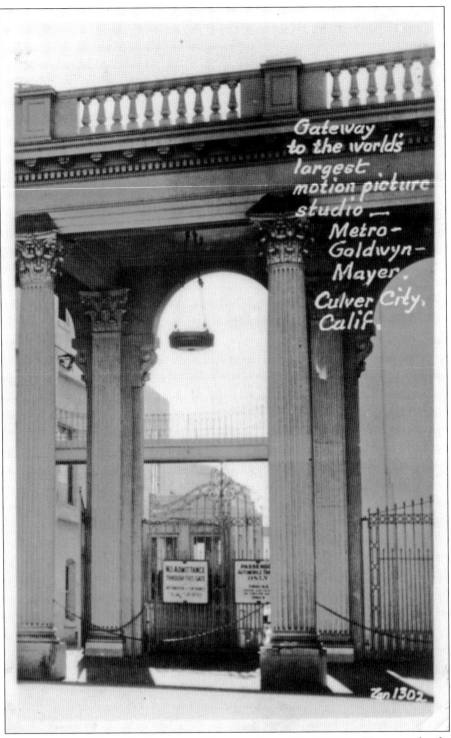

GATEWAY TO THE WORLD'S LARGEST MOTION PICTURE STUDIO. Here are the famous Metro-Goldwyn-Mayer gates on Washington Boulevard in Culver City. Through these gates passed the most notable actors and directors ever to work in the motion picture industry.

44

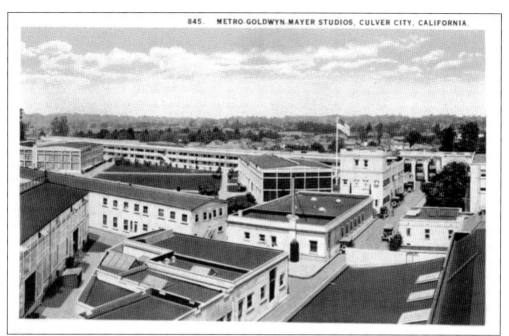

LUSTROUS MGM. By 1926, MGM had the best staff directors and stable of stars in the industry. With Irving Thalberg supervising feature film production, the studio began to produce "quality films." This view, looking north, shows stages to the left and the colonnade in the middle. (Published by Western Publishing and Novelty Company.)

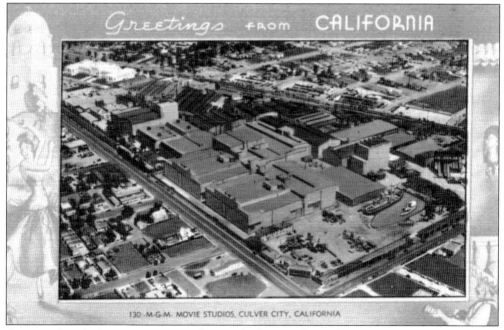

Greetings from CALIFORNIA

130 M-G-M MOVIE STUDIOS, CULVER CITY, CALIFORNIA

CULVER CITY'S CLAIM TO FAME. This aerial of MGM shows the stages, production buildings, and front sets (including a body of water) in 1935. By this time, the studio was the most prestigious lot in the business, boasting that it had more stars than up in heaven. (Published by Gardner-Thompson Company.)

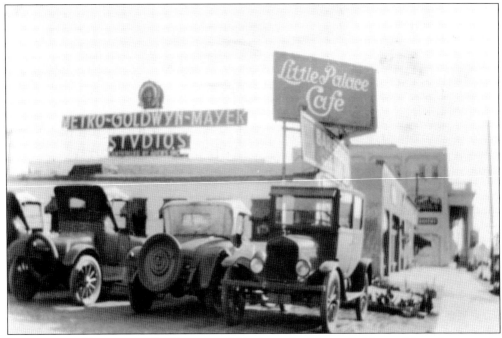

COLONNADE ENTRANCE. Parking was difficult at the Metro-Goldwyn-Mayer lot even in the old days. This is a view of the lot on Washington Boulevard looking west from past the colonnade entrance. MGM would eventually have 30 soundstages and cover 187 acres.

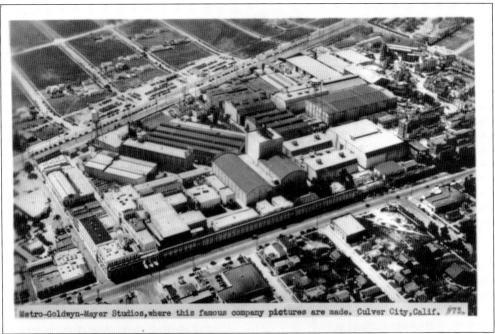

Metro-Goldwyn-Mayer Studios, where this famous company pictures are made. Culver City, Calif. #73.

ANOTHER MGM AERIAL VIEW. This mid-1930s aerial view of Metro-Goldwyn-Mayer Studios shows the front of the lot on Overland with numerous standing sets and two water towers. Today the water tower on the Culver Boulevard side of the lot is gone, and only the tower near Stage 15 still exists.

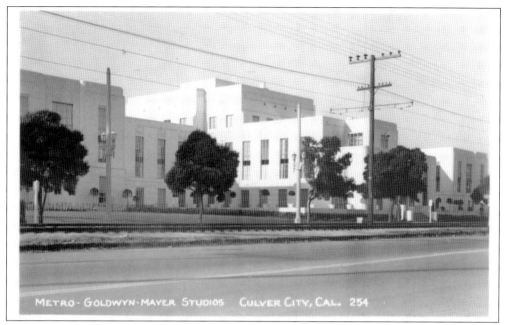

METRO-GOLDWYN-MAYER STUDIOS CULVER CITY, CAL. 254

THALBERG BUILDING. This angle of the MGM lot shows the south side of the Irving Thalberg Building from Culver Boulevard. The building, built in 1937 after the death of Thalberg, still stands today in 2007. Thalberg was pivotal in putting the unit producer element in place for the studio system. Under his supervision, Thalberg placed a dozen producers in charge of producing several films a year for the studio.

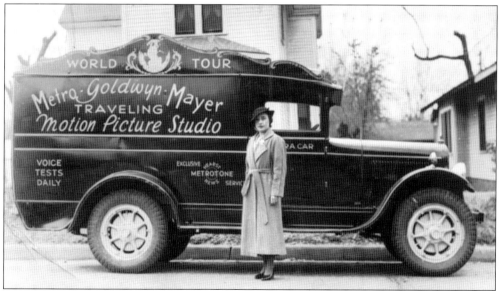

MGM WORLD TOUR CAR. MGM was always on the lookout for new talent. Sometimes talent scouts had to travel overseas to Europe to find talents like Swedish Greta Garbo or Austrian Hedy Lamarr. Sometimes it took a road trip around the United States in a traveling tour car like this one from the 1930s. When sound arrived in Hollywood, studios not only needed pretty faces, they also needed proper voices. This World Tour car had sound recording equipment that would test the voice of the talent found on the road.

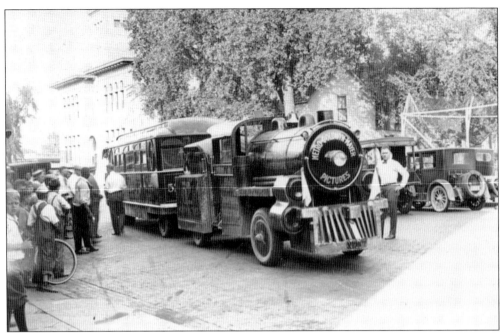

MGM PICTURES TALENT BUS. This MGM Movie Train was used to find talent in the late 1920s. Like the "Globe Trotter," it would travel throughout the United States promoting MGM films; studio talent scouts would also audition starlets wanting to become actresses in Hollywood.

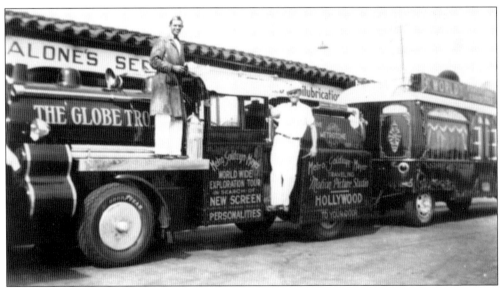

TRAVELING MOTION PICTURE STUDIO. The "Globe Trotter" needed some repairs in this 1936 image. From the text on the side of the vehicle, one can read that the *Hearst News*, through Metrotone, would provide exclusive service for Metro-Goldwyn-Mayer. When this was taken, MGM had a roster of talent that included Clark Gable, Greta Garbo, Jean Harlow, Spencer Tracy, Joan Crawford, and Wallace Berry.

IRVING THALBERG BUILDING. At the age of 25, Irving Thalberg was head of production at MGM and oversaw some of the studios' highest-quality productions. His demand for excellence placed him in a class all his own, and he never wanted to take credit for a film. Thalberg's legendary confrontations with Erich Von Stroheim on the *Foolish Wives* set are spoken about to this day. It was a tragic day in 1936 when Thalberg died. MGM studios closed its gates for the first time for his funeral, and every movie studio in Hollywood gave a moment of silence as a tribute to one of the greatest producers of motion pictures.

METRO-GOLDWYN-MAYER — CULVER CITY, CALIF.
ARTCO 575

TRACY AND HEPBURN. Here is a view of the Thalberg Building looking west. It has been said that it was on the west-side stairs of this building that Spencer Tracy and Katherine Hepburn met for the first time. (Published by Artco.)

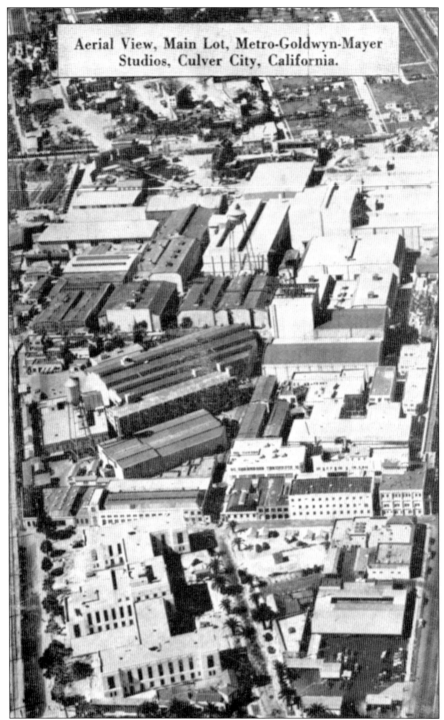

AERIAL VIEW, MAIN LOT. Here is an aerial view of the MGM Lot No. 1 looking west from this mailed card in 1941. Lot No. 2, on the west side of Overland, is at the top of the card. MGM had seven lots, and everything from a jungle lagoon to a New York street was available for any filmmakers' imagination. (Published by the Culver City Chamber of Commerce.)

Four

Fox

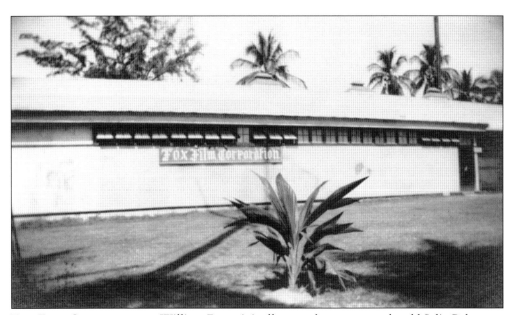

FOX FILM CORPORATION. William Fox originally rented out space at the old Selig Polyscope Studios in Edendale on Allesandro Boulevard. He opened his own studio after purchasing the old Dixon lot on Sunset Boulevard and Western. Here is a view of a bungalow with a "Fox Film Corporation" plaque written in Old English with palm trees surrounding the building.

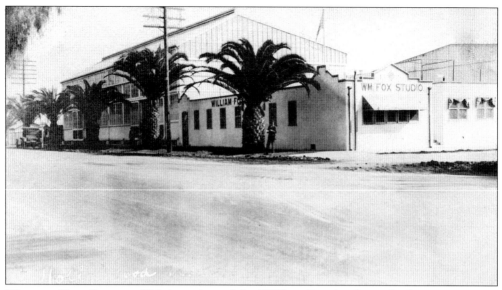

WILLIAM FOX STUDIO. This is a view of the William Fox Studio with glass stages in the background. The lot would go on to engulf both sides of the south corners of Sunset Boulevard and Western Avenue. It was on this lot that the enormous sets for *Cleopatra* were built in 1916.

WILLIAM FOX STUDIO BUNGALOW. William Fox began distributing motion pictures in 1909 in New York. In 1911, he moved to California and eventually opened up this studio in Hollywood. For another 14 years, Fox would operate from this location. In the late 1960s, this studio mostly produced television.

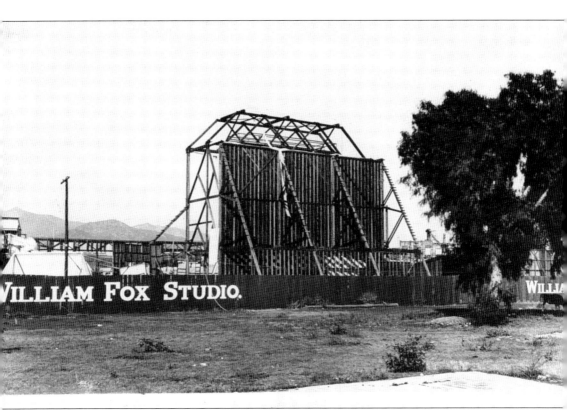

AT SUNSET AND WESTERN. Here is a look at a building going up at the William Fox Studio on the southeast corner of Sunset Boulevard and Western Avenue. Under the tree on the right side, a cow is eating in this still rural site of Hollywood in the early 1920s. By 1926, Fox had invested in recording sound on film with "Movietone" and soon would make the transition to "talkies." In 1929, the studio's prestige was elevated when Janet Gaynor was awarded the first Academy Award for best actress for the William Fox production of *Seventh Heaven*, and the same film was nominated for best picture.

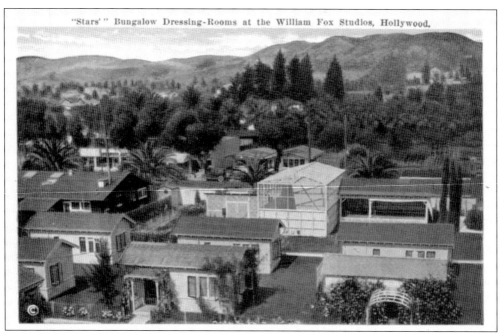

"Stars' " Bungalow Dressing-Rooms at the William Fox Studios, Hollywood.

"STARS" BUNGALOW DRESSING ROOMS. The William Fox Studios had beautiful bungalows for their "stars" on the Western lot. In this postcard, the Fox Cafeteria and Tom Mix's handball court and the boxing ring built for him for everyday workouts are visible. (Published by California Postcard Company.)

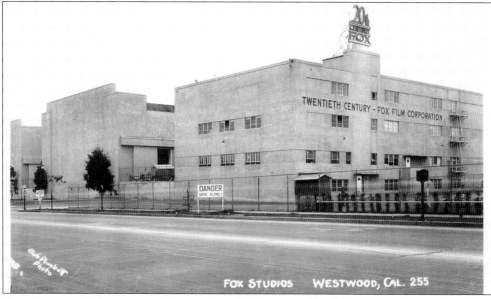

FOX STUDIOS, WESTWOOD. Fox purchased 300 acres of land just west of Beverly Hills in 1926 and built Movietone City. By 1929, the stock market had done William Fox in, and he was forced out of his company. Twentieth Century Pictures and Fox merged to form 20th Century-Fox in 1935, under the supervision of Darryl F. Zanuck. Seen here are the first stages in Hollywood built for the sole purpose of recording sound for motion pictures. (Published by Bob Plunkett.)

Twentieth Century-Fox. This is a view of production buildings on the 20th Century-Fox lot in the 1960s. By this time, Darryl F. Zanuck had appointed and then fired his son Richard Zanuck as head of production of the studio. It was also in this time of transition that Century City would begin to be created with the land that the studio was forced to sell because of the poor economics of the studio. (Published by Kolor Sales Ko.)

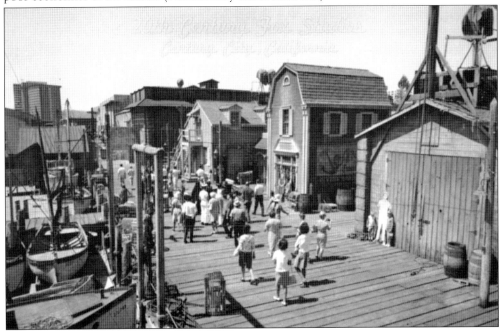

Twentieth Century-Fox Studios, Century City. In 1957, plans were unveiled for the creation of a residential and commercial venture called Century City. The land is situated on the former back lot of 20th Century-Fox and is now encompasses over 175 acres. By 1963, the first building was completed, and the studio had spent $44 million to make *Cleopatra*. (Published by 20th Century-Fox.)

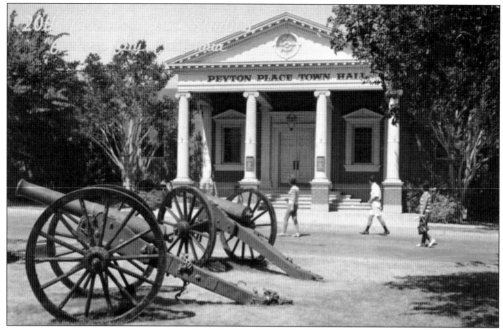

PEYTON PLACE. This is a view of the Peyton Place Town Hall and cannons in the 20th Century-Fox back lot. *Peyton Place* was filmed for the studio in 1957 and starred Lana Turner. The material was then used to create a television series in the 1960s, which ran for several years. (Published by 20th Century-Fox.)

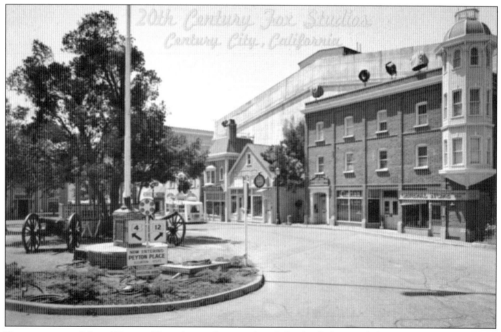

REPLICATING NEW YORK. Here is another angle of the back lot used for *Peyton Place*; the tall buildings behind the city street are soundstages. Today the New York portion of the back lot is used frequently for commercials, television, and feature films. (Published by 20th Century-Fox.)

Five

WARNER BROTHERS

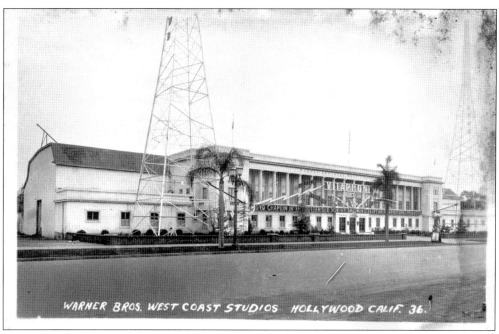

WARNER BROTHERS WEST COAST STUDIOS. Jack and Harry Warner built this movie studio on the southeast corner of Sunset Boulevard and Bronson in 1919. It was here in 1927 that Al Jolson would sing in *The Jazz Singer* on Stage 5, which would make history as the first talking motion picture. This 1926 card shows the front of the building, advertising Syd Chaplin in *The Better 'Ole*. VITAPHONE can be read on the columns of the facade.

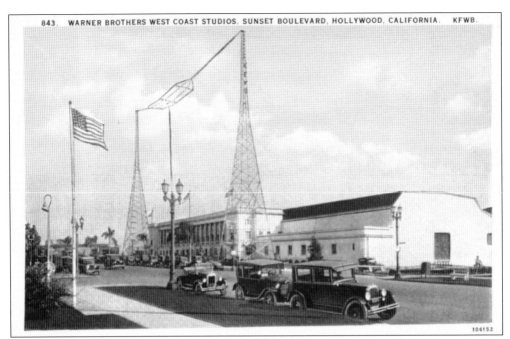

WARNER BROTHERS IN HOLLYWOOD. Looking east on Sunset Boulevard in the late 1920s, the Warner Brothers Studios on Sunset Boulevard and Bronson is visible. The two tall towers are antennas for KFWB, a radio station inaugurated in 1925. It is still argued that the letters are an acronym for "Keep Filming Warner Brothers." (Published by Western Publishing and Novelty Company.)

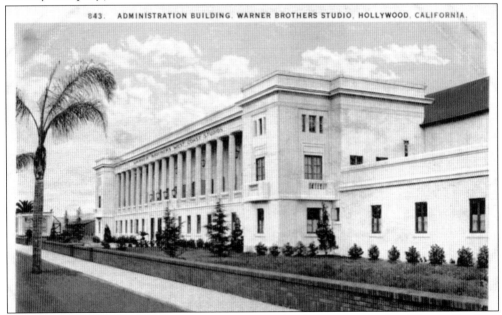

ADMINISTRATION BUILDING. Pictured here in the late 1920s is the Warner Brothers Administration Building on Sunset Boulevard. At this time, Warner Brothers had operations at the old Vitagraph lot, the Sunset lot, and the First National lot in Burbank. (Published by Western Publishing and Novelty Company.)

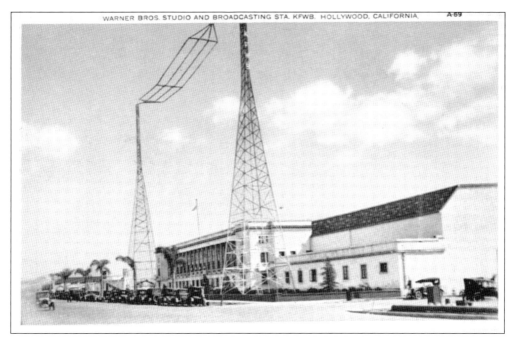

WARNER BROTHERS STUDIOS AND BROADCASTING STATION. KFWB in Hollywood was based at Warner Brothers. Comparing this view to the image on the previous page, note that the stage door in the middle of the card on the right has been covered, possibly because it now led to a soundstage. Warner Brothers was considered the pioneers of sound in motion pictures. (Published by Pacific Novelty Company.)

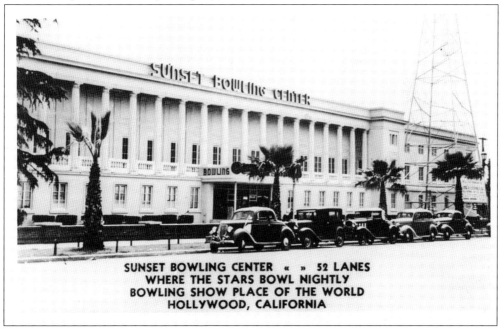

SUNSET BOWLING CENTER « » 52 LANES
WHERE THE STARS BOWL NIGHTLY
BOWLING SHOW PLACE OF THE WORLD
HOLLYWOOD, CALIFORNIA

SUNSET BOWLING CENTER. It is hard to believe, but at one point, this historical site in the motion picture industry became a bowling alley. Fifty-two lanes were advertised for the Sunset Bowling Center on the former Warner Brothers West Coast Studios lot.

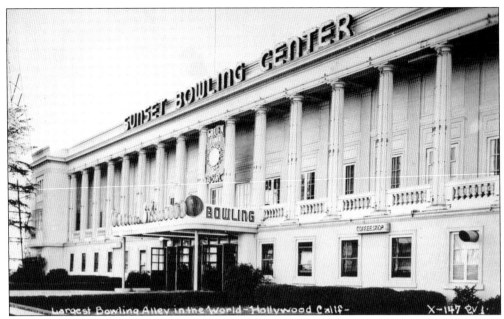

LARGEST BOWLING ALLEY IN THE WORLD. Here is an eastern view of the largest bowling alley in the world in the late 1940s. The administration building used by the Warner Brothers West Coast Studios had turned into a recreational center for Hollywood. Beautiful neon was used to lure patrons into the former movie studio, and cars pulled up and parked on Sunset Boulevard.

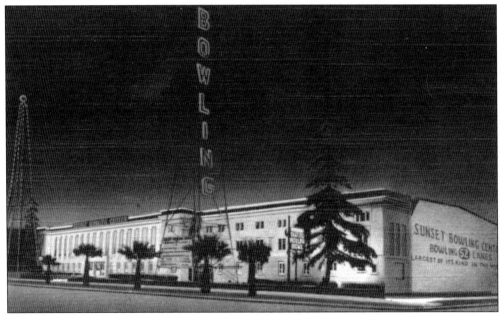

MORE SUNSET BOWLING CENTER. A look at the Sunset Bowling Center at night reveals beautiful, red neon outlining the letters on the building's facade on Sunset Boulevard. There was more than 10,000 feet of Fluron lighting used to advertise the 52-lane alley. The venue also had a café, cocktail bar, locker rooms, and showers for customers. (Published by Curteich-Chicago.)

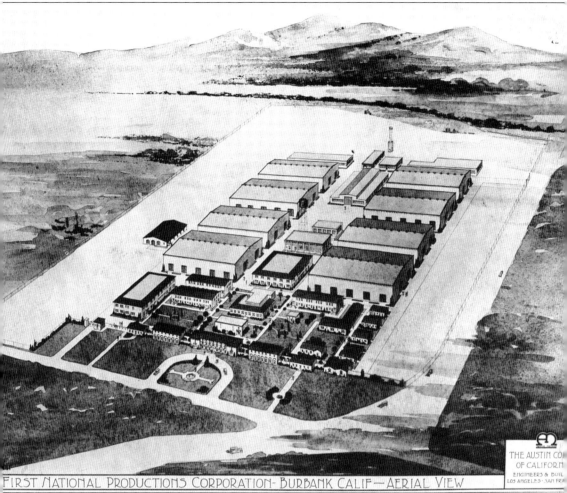

FIRST NATIONAL PRODUCTIONS CORPORATION- BURBANK CALIF—AERIAL VIEW

THE AUSTIN CO.
OF CALIFORN
ENGINEERS & BUIL
LOS ANGELES · SAN FRA

FIRST NATIONAL PRODUCTIONS CORPORATION, BURBANK. This is the Spanish Revival–style model proposed to First National Pictures by the Austin Company of California in 1926. These architects and engineers began construction of First National Pictures Studios on a piece of land that included a 78-acre alfalfa field previously owned by Howard G. Martin. Twenty-one structures were completed by October 1926, including four soundstages and the administration complex. (Published by the Austin Company of California.)

FIRST NATIONAL PICTURES. First National Pictures had spent $2.5 million constructing the Burbank studio by the time Warner Brothers purchased the lot in September 1928. This image, dated August 1928, shows three soundstages completed on the lot, bringing the total number of structures to 27.

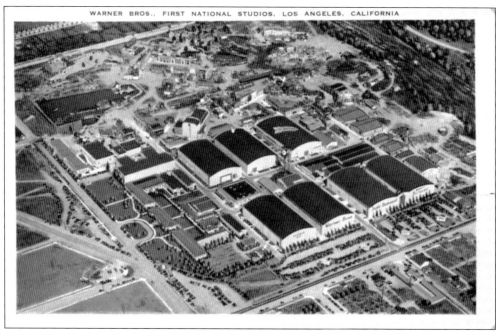

WARNER BROTHERS, FIRST NATIONAL PICTURES. In this 1935 aerial view of the Warner Brothers/First National Pictures lot, one can see the back lot sets erected at the top of the card. The original water tower location was next to the generator plant, located in the center of the card. (Published by E. C. Kropp Company.)

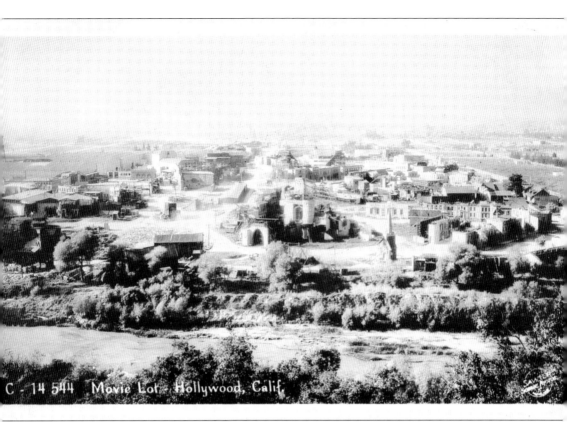

C - 14 544 Movie Lot - Hollywood, Calif.

MOVIE LOT—HOLLYWOOD. Warner Brothers' enormous back lot in the late 1930s is seen in this view looking west towards the stages and administration building. In 1937, the Mill was built to store sets and walls and the property building was completed. By this time, the studio had 25 stages available for motion picture production.

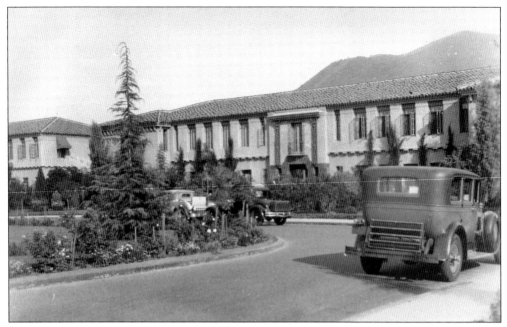

ADMINISTRATION BUILDING. The Administration Building was one of the original structures completed on the lot in 1926. This view looks south from the front entrance along the circular driveway.

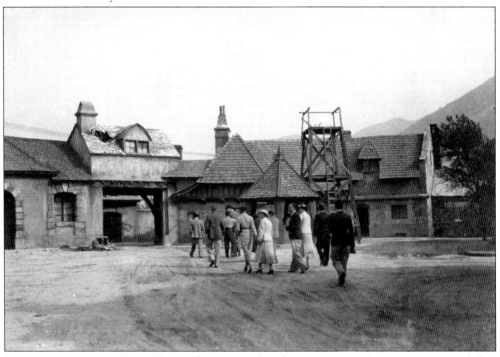

VILLAGE SET, BACK LOT. Tours of movie studios began once motion pictures started, but it was not until Universal formally introduced it to the regular operations of the facility that it flourished as an avenue for revenue. Here a group walks through an old village set in the Warner Brothers back lot in the early 1930s.

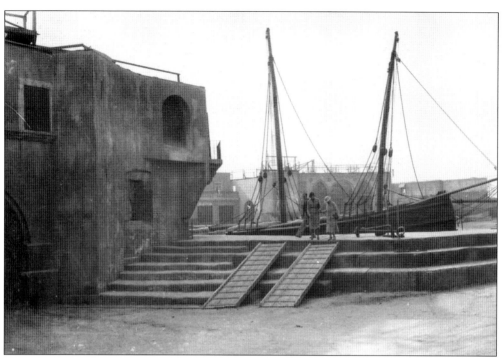

WATER TANK, BACK LOT. A huge ship sits in the water tank on the Warner Brothers back lot. Standing exterior sets in the back lot were first introduced on the eastern side of the studio the same year it was built. Having a controlled environment within the confines of the studio is an advantage to both location shooting and production costs.

CHINESE VILLAGE, BACK LOT. On the Warner Brothers back lot, facades were created to look like a Chinese village. Practically all of these exterior sets are gone because of numerous fires and updating. The Brownstone street, built in 1929, is the oldest back lot set still intact today.

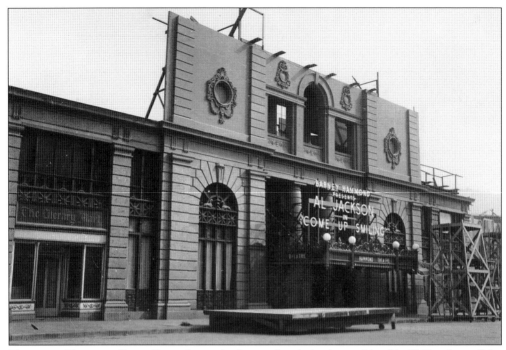

THEATRE FACADE, BACK LOT. A movie theatre facade is pictured in this 1930s view of the back lot. The New York street set on the Warner Brothers back lot is rich with history and was shown in films like *The Roaring 20s, Public Enemy,* and *The G Men* to name a few.

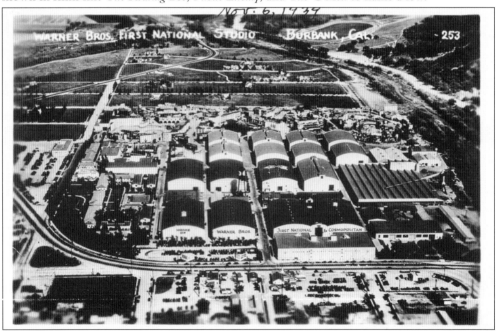

AERIAL OF WARNER BROTHERS. This aerial view of the Warner Brothers First National Studios is dated November 6, 1939; however, because the front stage includes Cosmopolitan Pictures, it would have been taken several years earlier. Cosmopolitan Pictures was a production company created for Marion Davies by William Randolph Hearst but dissolved in 1937.

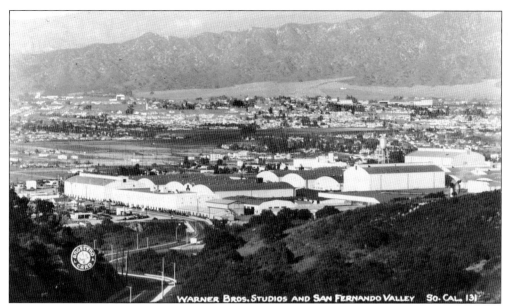

WARNER BROTHERS STUDIOS AND SAN FERNANDO VALLEY. In this late-1930s view of the Warner Brothers Studios, one can see most of the stages on the lot coming up and around the hill from Barham Boulevard. Stage 16, considered the tallest stage in the world, was elevated 30 feet in 1936 for *Cain and Mabel* at the order of William Randolph Hearst's Cosmopolitan Pictures. (Published by Angeleno Card.)

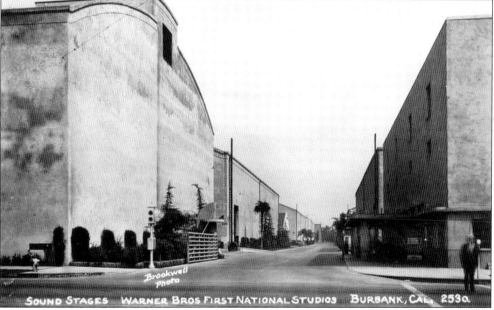

SOUNDSTAGES AT WARNER BROTHERS. In 1937, Gate No. 2 looked very much like it does today—except it is missing the security guard booth in the center of the road. Most of the stages on the west side of Warner Brothers are now dedicated to television series. If anyone drives by this section of the studio at 6:00 a.m., they will see hundreds of studio employees waiting in line to go through an ID check and metal detector to get into the studio gates. (Published by Brookwell Photo.)

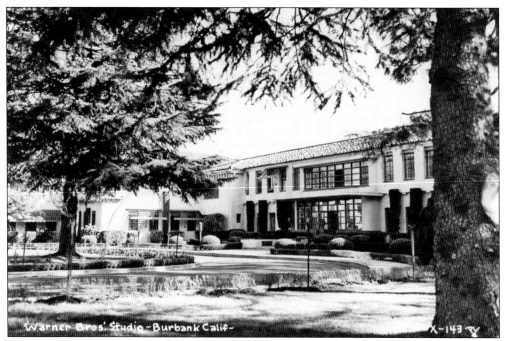

WARNER BROTHERS STUDIOS, BURBANK. Trees and flowers surround the Warner Brothers Studios Administration Building in this view from the late 1930s. Windows have replaced the bas-relief entrance to the building at this point in time. The studio continues to make over its look and has always been visually pleasing to the community.

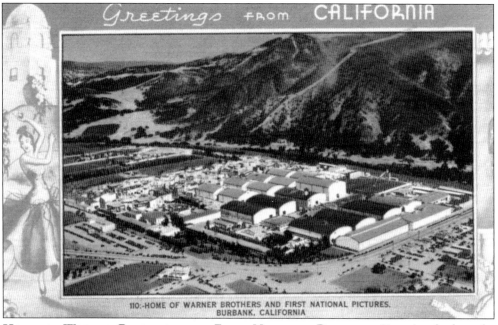

HOME OF WARNER BROTHERS AND FIRST NATIONAL PICTURES. Here is a look at the Warner Brothers and First National Pictures Studio from the early 1930s. At this time, 70 percent of the motion pictures in the world were created in Los Angeles. (Published by Gardner-Thompson Company.)

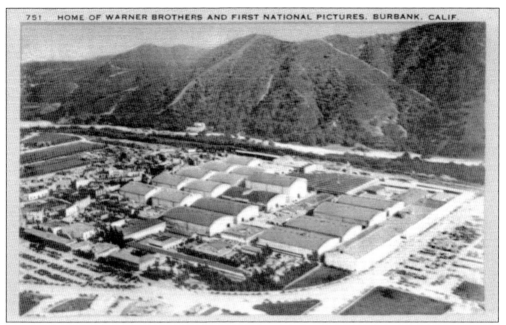

MARITIME STAGE. By 1946, Warner Brothers Burbank had 50 structures on the lot, including several more stages. Stage 21, completed in 1940 for Michael Curtiz's *The Sea Hawk*, was called the "Maritime" stage because it held a huge tank and had a submersible floor. When it came time to move *The Albatross*, the main ship set, they had to drive it through the back lot to get it onto the stage. (Published by Longshaw Card Company.)

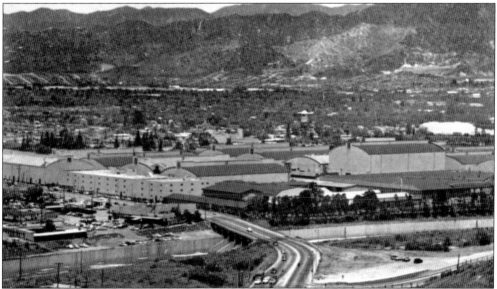

WARNER BROTHERS PICTURES, INC. The roofs of the stages resemble terra-cotta tiling in this early-1950s card. In the distance are the Verdugo Mountains and the San Fernando Valley. In the center of the card is the water tower, which proudly displays the famous WB logo, in its new location near the Hollywood Way gate. From 1972 to 1989, the studio could not display the logo because the lot, known as Burbank Studios, was shared with Columbia Pictures. (Published by Western Publishing and Novelty Company.)

69

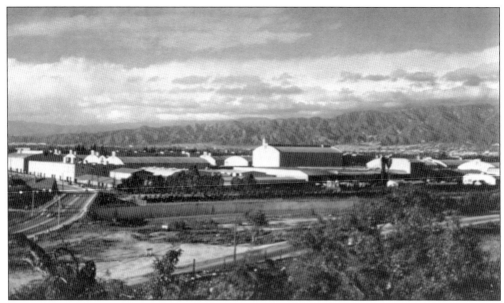

WARNER BROTHERS ROOFS. In this card, the stage roofs on the Warner Brothers lot are now gray. Two fires damaged exterior sets—German street and Western town—in 1952. Stage 21 was also destroyed. (Published by Mike Roberts Color Reproduction.)

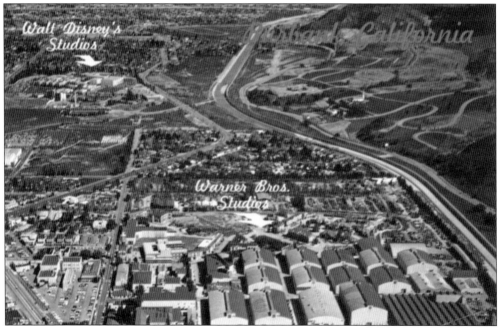

BURBANK, CALIFORNIA. This aerial of Burbank shows both the Warner Brothers Studios and the Walt Disney Studios at the top left. Many changes have occurred to the Warner Brothers back lot since this card was printed. Today Laramie Street, the last Western street, has been replaced with Warner Village. Memorable sets are gone, including a full-size railroad, the castle from *Camelot*, Spanish street, and many others. However, the 1956 Jungle remains as well as homes on Midwest Street where *Kings Row* and *East of Eden* filmed. (Published by Western Publishing and Novelty Company.)

Six

PARAMOUNT

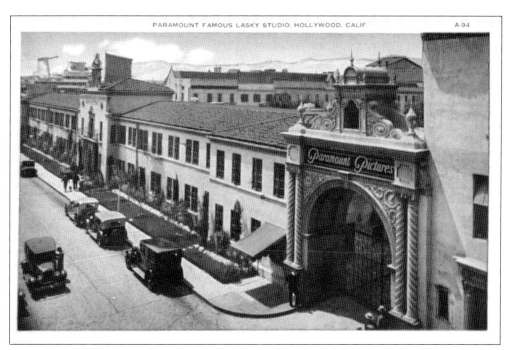

PARAMOUNT FAMOUS LASKY STUDIO. Paramount Pictures took over the old Paralta Studios in 1926 and continue to run operations from this location today. Pictured here in the late 1920s are the iron gates on Marathon Street, which was once open to the public. The Western Costume Company was down the block. Today this street is inside the Paramount lot, and the Western Costume Company building has been torn down to make room for more parking and structures at the studio. (Published by Pacific Novelty Company.)

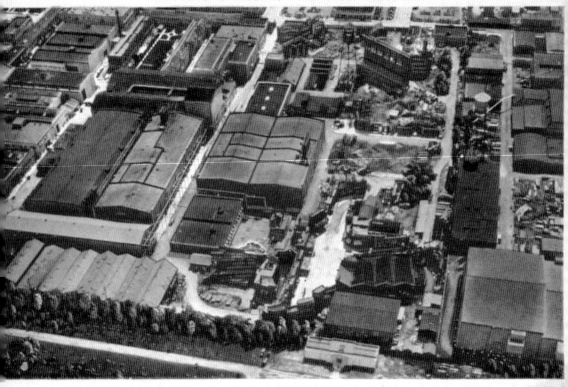

PARAMOUNT'S STUDIOS AERIAL. This early-1930s view of Paramount Studios shows the 14 soundstages and exterior sets in the back lot. Paramount covered 26 acres and eventually expanded the lot at a cost of $1 million. (Published by E. C. Kropp.)

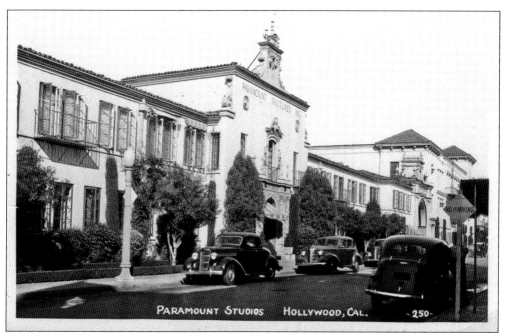

PARAMOUNT STUDIOS ADMINISTRATION BUILDING. This late-1930s view looking east shows the Administration Building on Marathon Street. Just south of this location is Valentino Place. Even though Rudolph Valentino never set foot on this lot, it pays tribute to one of Paramount's most famous actors.

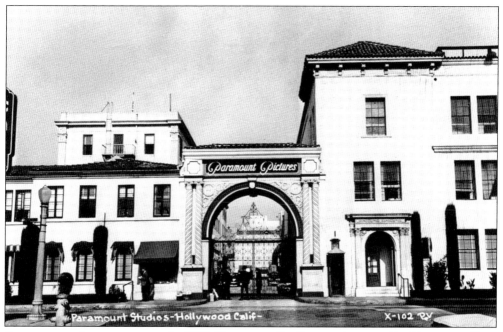

PARAMOUNT ICONOGRAPHY. In 1950, Paramount Studios was immortalized in a scene from *Sunset Boulevard* when William Holden, Erich Von Stroheim, and Gloria Swanson drive up to get into the studio. Today the building to the right is named after Charles Bluhdorn, chairman of Gulf and Western Industries.

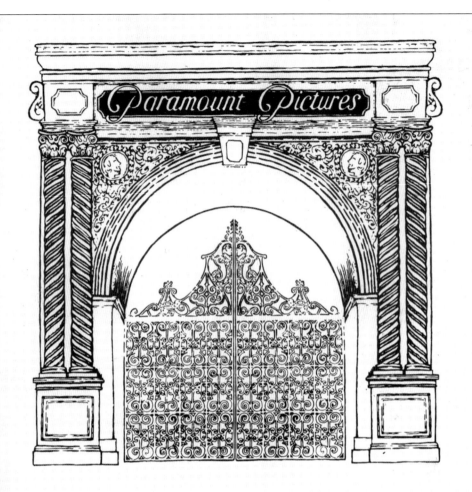

Paramount Pictures

№ 64982

STUDIO TOUR

HOLLYWOOD, CALIFORNIA

PARAMOUNT PICTURES TOUR. Pictured here are the iron gates designed by Ruth Morris. Movie studio tours are one of the main attractions for tourists that come to Hollywood. Paramount provides a comprehensive two-hour studio tour of the 62-acre lot Monday through Friday. (Published by Paramount Pictures.)

Seven

HOLLYWOODLAND

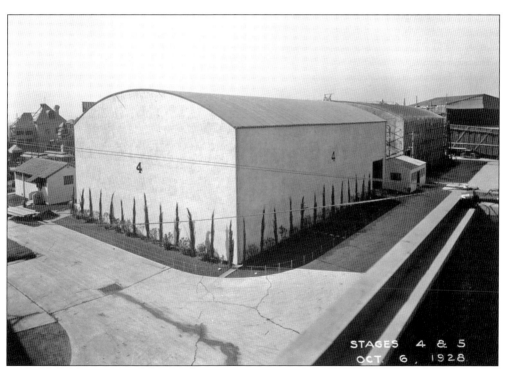

UNITED ARTISTS. Stages 4 and 5 are being constructed for the United Artists lot on Santa Monica Boulevard and Formosa on October 6, 1928. This 13-acre studio was quite special because it was created by Charlie Chaplin, Mary Pickford, and Douglas Fairbanks, the biggest stars in Hollywood when United Artists was formed. All around town was heard, "the inmates have taken over the asylum." To this day, on Santa Monica Boulevard, a bas-relief crested entry with two classical figures gaze westward with United Artists written under them. It is located above an entryway that has been covered and, at the moment, leads nowhere.

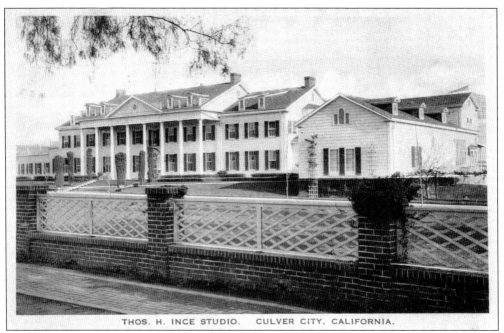

THOS. H. INCE STUDIO. CULVER CITY, CALIFORNIA.

THOMAS H. INCE STUDIO. In 1918, after Triangle Pictures had dissolved, Thomas Ince built this movie studio on Washington Boulevard in Culver City not far from Triangle Studios, which were now in the hands of Sam Goldwyn. The studio covered 13.95 acres. Ince built his famous Administration Building, which was modeled after George Washington's Mount Vernon home, in the front of the studio. (Published by the Albertype Company.)

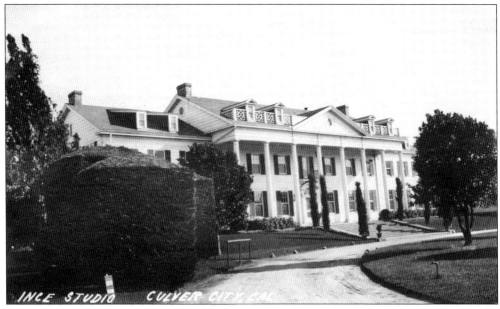

INCE STUDIO IN CULVER CITY. Looking west from the circular driveway to the Ince Studio Administration Building in the late 1910s, note the railing in the middle of the card used to tie up a horse if one came riding up to the studio. This card, mailed on August 20, 1923, to Kaysville, Utah, reads in part, "Seen a number of pictures staged in front of building."

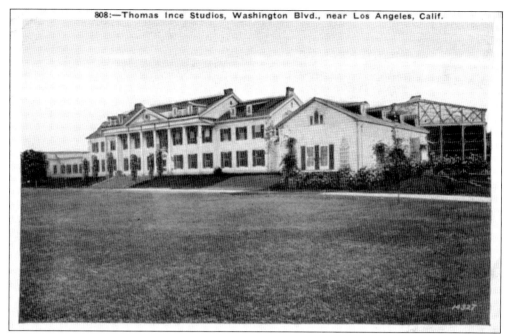

INCE STUDIOS, WASHINGTON BOULEVARD. It has been said that Thomas Ince conceived the idea of using glass stages to take advantage of the sunlight, and, as he did at Triangle Studios, Ince had them built at his new studio. Stage 1 is behind the Administration Building in this card from around 1918. Ince employed natural sunlight because artificial lighting was still considered "clumsy" and had not reached the level needed to shoot consistently. (Published by M. Kashower Company.)

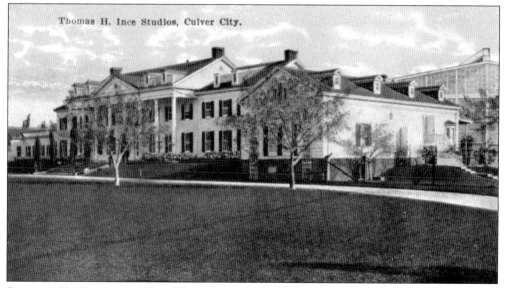

Thomas H. Ince Studios, Culver City.

SPARING NO EXPENSE. When Thomas Ince built this studio in 1918, he spared no expense. It included paint shops, a mill, projection rooms, a scene dock, editing rooms, and this beautiful Administration Building. Three glass stages, four-sided glass enclosures that captured natural sunlight for an extended period of the day, were constructed to Ince's specifications. (Published by California Postcard Company.)

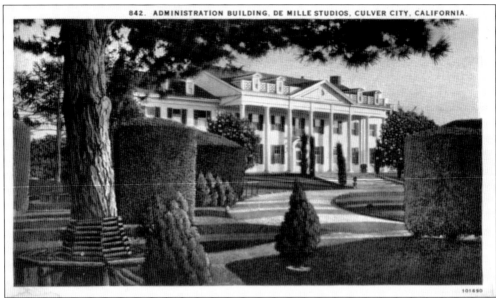

ADMINISTRATION BUILDING, DEMILLE STUDIOS. After Thomas Ince died on November 19, 1924, it was said that Ince's widow would only allow someone like Cecil B. DeMille to take over the lot. It was at this studio that *The Ten Commandments*, *The Greatest Story Ever Told*, and *King of Kings* were made. Because of the content of DeMille's films, he found it costly to produce such spectacles on his own and could not continue to make films and run his own studio. (Western Publishing Company.)

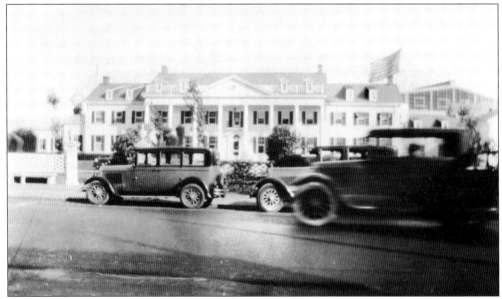

DEMILLE STUDIOS. Cecil B. DeMille was very vocal about picking his material and hiring his own crew, so it was inevitable that he wanted total control over his films, and in 1925, he announced he was purchasing the Ince lot. The DeMille Studios tenure lasted for about three years. This image, from August 1928, shows the Administration Building. It was not long after this photograph was taken that DeMille left the lot, went back to Paramount, and continued to amaze the world with his lavish productions.

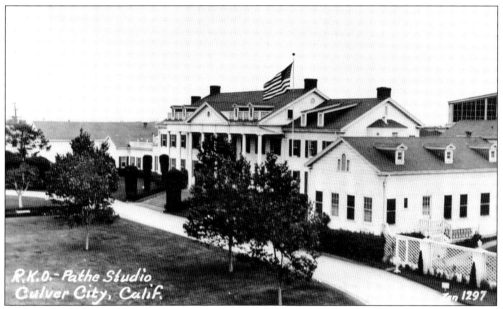

RKO-Pathe Studio. The circular driveway in front of the Administration Building was paved in cement by the time Pathe took over the Ince lot in 1928. Pathe was a newly formed company and was not entirely prepared for making the costly studio transition to sound. RKO merged with Pathe in 1930, and RKO remained on this Culver City lot until the mid-1950s. (Published by Zan of Tamalpais.)

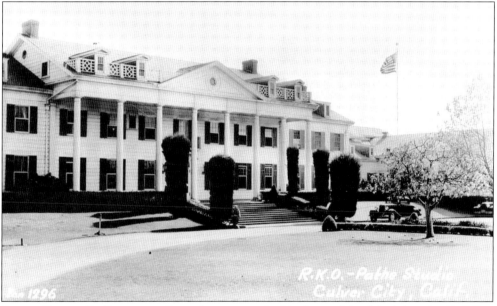

Enter David O. Selznick. Several cars are parked in front of the Administration Building of RKO-Pathe Studio in this card from the early 1930s. One of the biggest problems this studio had when they took over the lot from DeMille was that they did not have anyone to run the studio operations. Enter David O. Selznick, who had recently resigned from Paramount. He came to RKO-Pathe as head of production for the Culver City lot. It was rumored early on that he once told his wife that his name would be above the front columns one day.

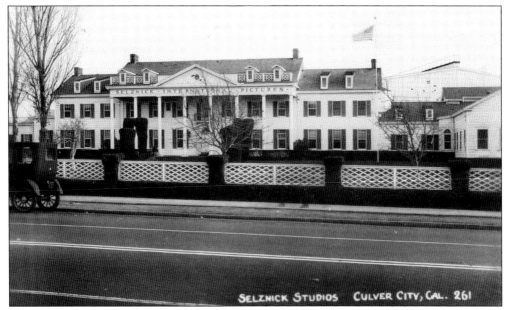

SELZNICK STUDIOS, CULVER CITY. David O. Selznick is considered one of the greatest motion picture producers to ever be in the business. This is an image of Selznick Studios around 1937, when he was heavy into the preparation for *Gone With the Wind*. Selznick International Pictures was written on the columns above the Administration Building of the former Ince Studio and would also introduce the beginning of his films.

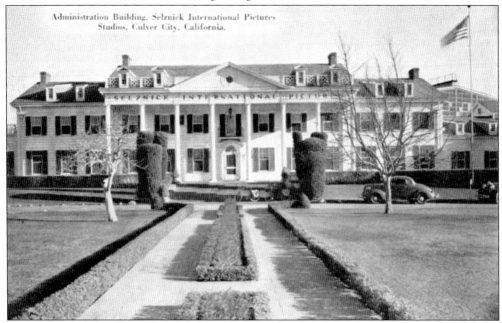

SELZNICK'S ADMINISTRATION BUILDING. One of the most recognizable images of any movie studio, the Selznick International Pictures Administration Building in Culver City will live forever—every time *Gone With the Wind* is screened, this image appears before the film. David O. Selznick ran SIP, and later Vanguard Films for over 30 years, from this building. (Published by the Culver City Chamber of Commerce.)

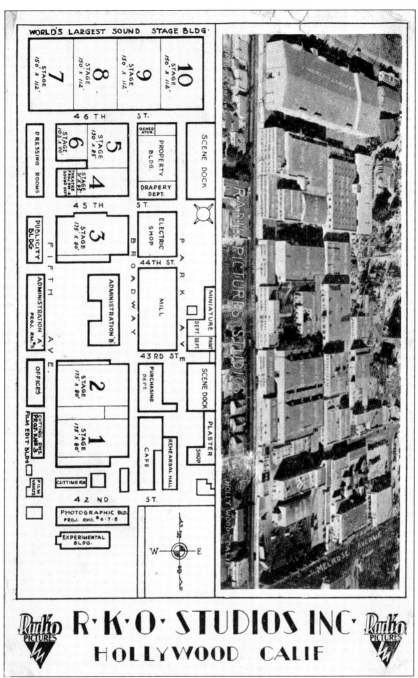

RKO Studios, Hollywood. On the corner on Melrose Avenue and Gower Street were the RKO Radio Studios. This wonderful card shows the layout of the lot, which included 10 stages and boasted "The World's Largest Sound Stage Building." Today Stages 29–32 have been respectively numbered in the same area as Stages 7–10 of the studios' past. RKO took over the FBO Studios in 1928 and ran studio operations from the 780 Gower Street address until 1957. Adjacent to the lot on the east was Paramount Studios, and the property line to the north is still Hollywood's oldest cemetery. (Published by RKO Studios.)

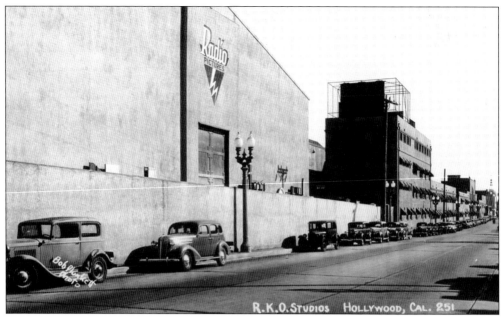

RKO Stood for Radio, Keith, Orpheum. Here are the RKO Studios on Gower Street in the late 1930s. Little has changed over the years in this southeast view of the lot. Howard Hughes would eventually buy RKO in 1948, when he purchased a quarter of the studio's stock. It was said that he operated RKO from his Caddo Pictures office on Romaine Avenue as much as he could so he would not be physically interrupted while tending his daily personal transactions. (Published by Bob Plunkett Photo.)

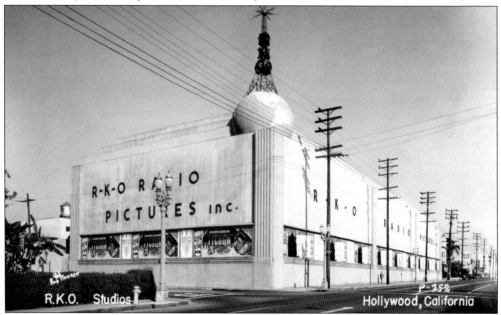

RKO at Melrose and Gower. Here, in 1947, RKO Studios is visible from the corner of Melrose Avenue and Gower Street. The billboard on the wall of what is now Stage 21 advertises John Wayne in *Tycoon*, the studio's biggest flop that year, losing over $1 million. (Published by Bob Plunkett.)

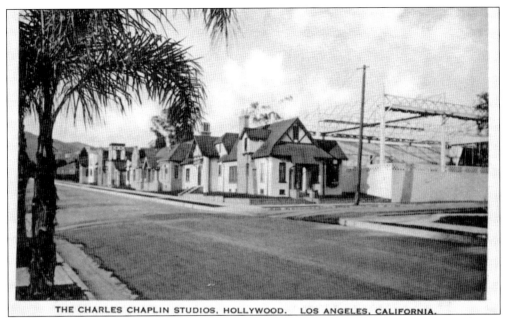

THE CHARLES CHAPLIN STUDIOS, HOLLYWOOD. LOS ANGELES, CALIFORNIA.

THE CHARLES CHAPLIN STUDIOS. Charlie Chaplin began building his movie studio on DeLongpre and La Brea in 1917, and it was completed along with this Tudor facade in 1918. Chaplin built his home adjacent to the studio on the north side, facing Sunset Boulevard. He enjoyed playing tennis and had a court built on the east side of his home. The court was located north of the laboratory of the studio. (Published by Western Publishing and Novelty Company.)

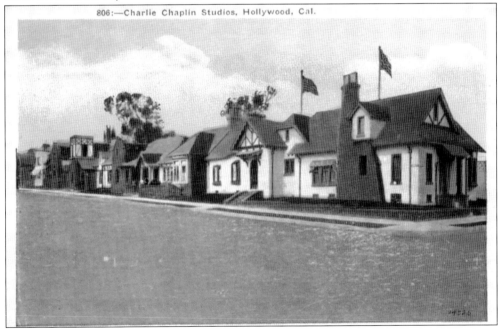

806:—Charlie Chaplin Studios, Hollywood, Cal.

CHARLIE CHAPLIN STUDIOS, HOLLYWOOD. Charlie Chaplin's studios on La Brea have changed names several times, but they continue to provide Hollywood production space. Chaplin thought about the construction of this studio very much and was happy to include a swimming pool, located north of the property room. (Published by M. Kashower Company.)

83

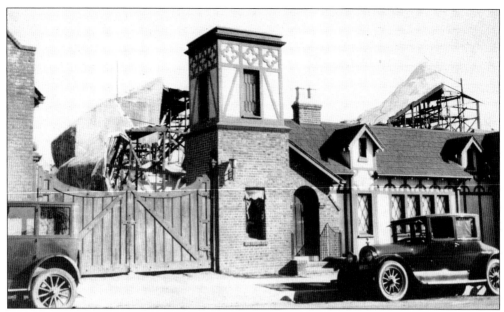

CHAPLIN GOLD. Here is a view of the lot looking east with the mountain set for *The Gold Rush* bursting out from the center of the studio in 1925. Chaplin wrote in his autobiography that he came up with the idea for the film while eating breakfast with Douglas Fairbanks at the home he shared with Mary Pickford, known as Pickfair. After constant pressure from Fairbanks and Pickford, *The Gold Rush* was Chaplin's second release for the recently formed United Artists and went on to gross over $6 million.

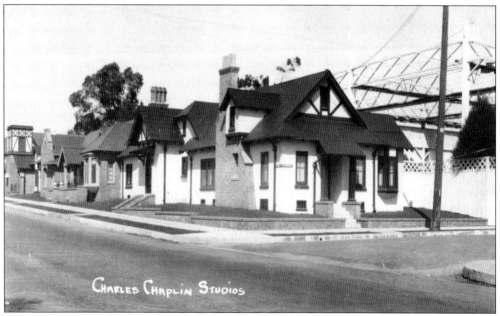

LA BREA AND DELONGPRE. This beautiful real-photo postcard of the Charlie Chaplin Studio shows the street names of La Brea Avenue and Delongpre Avenue on the farthest southwest part of the lot. An old map of the studio reveals this section of the building to be Chaplin's old dressing room.

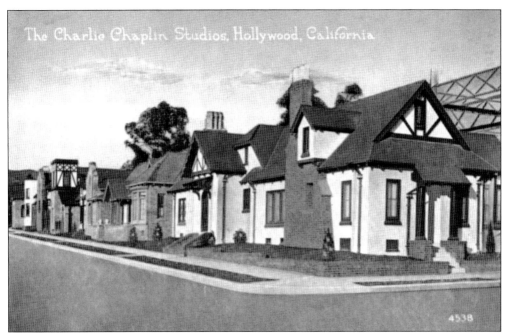

TRAMP'S STUDIOS. Charlie Chaplin built his studio with a glass stage that had about 10,000 square feet. Adjacent to the stage was a scenery storage room, a property room, a production office, and a dining room. The Tudor facade housed dressing rooms, a projection room, general offices, bathrooms, and production office space. (Published by California Postcard Company.)

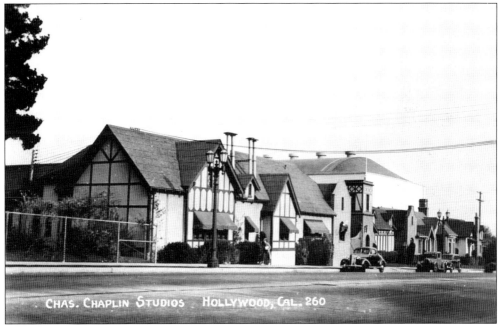

MORE ON THE GLASS STAGE. By 1937, the Charlie Chaplin Studios had modified the glass stage, rebuilt it for sound, and included an arbor system for lighting. Chaplin had already completed *Modern Times* and was preparing *The Great Dictator* at the time this image was taken. Before *The Great Dictator* was completed, England had declared war on Germany.

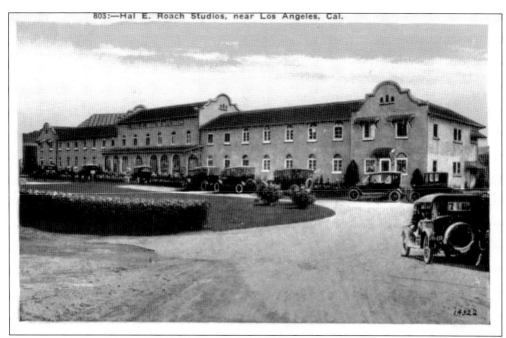

HAL E. ROACH STUDIOS. When the Hal Roach Studios opened in 1919, the lot was nicknamed "The Lot of Fun." It was here that Laurel and Hardy, Harold Lloyd, Charley Chase, Snub Pollard, and the "Our Gang" films were produced. This is a view of the studio on Washington Boulevard in the early 1920s. (Published by M. Kashower Company.)

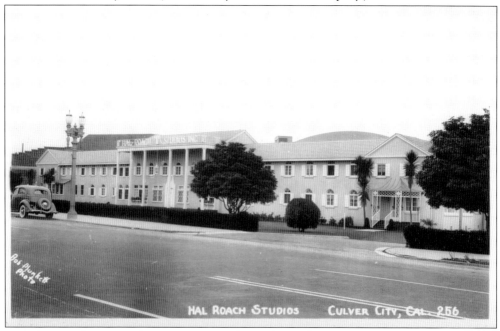

HAL ROACH STUDIOS, CULVER CITY. Hal Roach purchased 14.5 acres from Harry Culver in 1919 and built his movie studio, showcasing some of the finest comedians ever to grace the screen. This image was taken about the same time Roach was producing *Topper* with Cary Grant and Constance Bennett in 1937. (Published by Bob Plunkett Photo.)

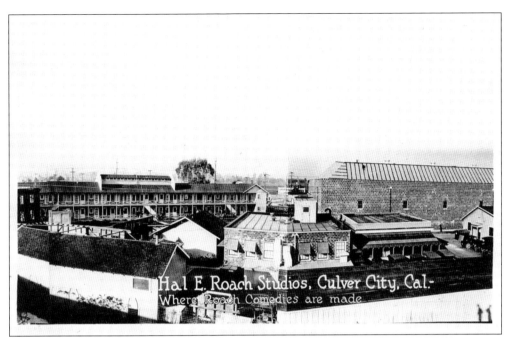

ROACH COMEDIES WERE MADE IN CULVER CITY. This image of the Hal Roach Studios is from the late 1930s. The studio was rewired for sound, and Roach had all the ingredients in place to make the transition to sound comedies with the "Our Gang" films. From 1922 to 1938, the Hal Roach Studios produced 168 "Our Gang" shorts. Laurel and Hardy also survived the move to sound but left the Roach lot in 1940 after making *Saps At Sea.*

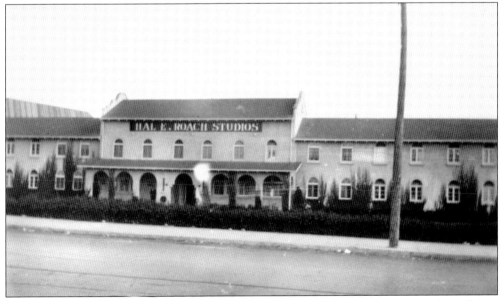

ONE-HUNDRED-YEAR-OLD ROACH. Hal Roach won two Academy Awards and was presented with an honorary Academy Award before dying at the age of 100 in 1992. Roach was one of the pioneers of short-reel comedies when the world was in dire need of laughter. His Culver City studio was demolished in 1963, but the wit of Will Rogers, the timing of Harold Lloyd, and the comedy of Laurel and Hardy will live on forever.

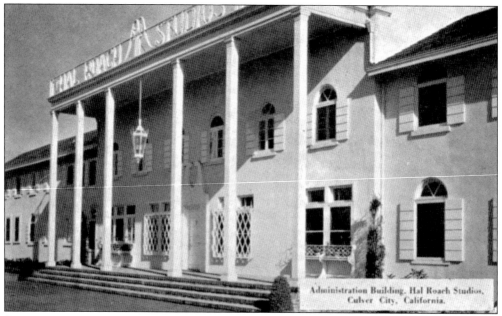

ADMINISTRATION BUILDING, HAL ROACH STUDIOS. Here is a view of the Hal Roach Studios Administration Building looking east. This card was mailed in November 1941, one month before the United States declared war on Japan. During World War II, Hal Roach rejoined the service and was stationed overseas as a lieutenant colonel. The Hal Roach Studios were used by the U.S. government to make training films during the war. (Published by the Culver City Chamber of Commerce.)

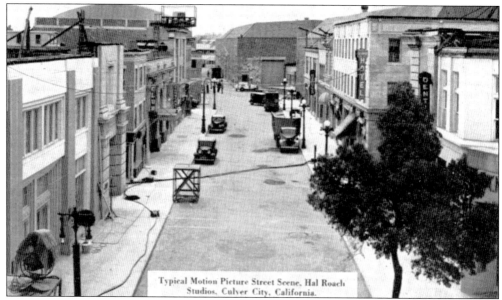

STREET SCENE, HAL ROACH STUDIOS. This is the back lot of the Hal Roach Studios in the early 1940s. Hal Roach concentrated on television production after the war, and the lot was busy until the mid-1950s. In November 1992, Hal Roach died at the age of 100, and comedians around the world laughed and smiled in honor of the wonderful man who was known as the "King of Comedy." (Published by the Culver City Chamber of Commerce.)

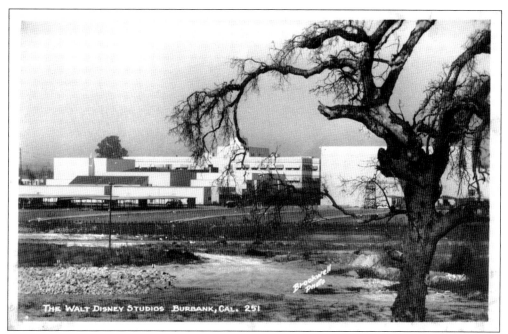

THE WALT DISNEY STUDIOS, BURBANK. Walt Disney opened this Burbank studio in 1939 with profits from *Snow White and the Seven Dwarfs*, which was the first animated feature-length film in English and in Technicolor. People say that Hollywood has produced three geniuses: Charlie Chaplin, Irving Thalberg, and Walt Disney. It would be hard to deny Disney's talent since he holds the record for the most Academy Awards. (Published by Brookwell Photo.)

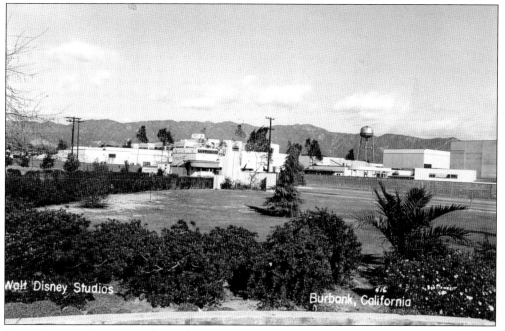

WALT DISNEY STUDIOS. The Walt Disney Studios are visible in the late-1940s view looking east, and a keen eye can spot the cross and structure for St. Joseph's Hospital in the center of the card. (Published by Angeleno Photo Service.)

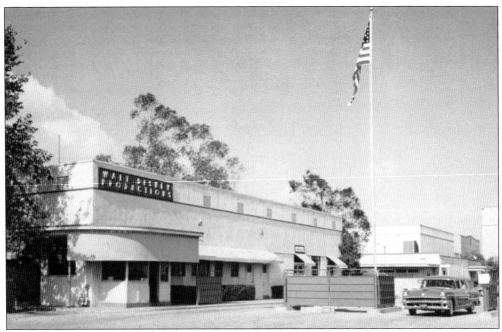

DISNEY STUDIOS. At the time of this 1950s image, Walt Disney Studios occupied 60 acres of land in Burbank. When Disney was alive, there were four stages built on the lot. The Disney back lot consisted of a Western street, the Zorro Pueblo, a residential street, and a town square. Today there are seven soundstages, and the back lot has been replaced with a parking lot and production buildings. (Published by Columbia.)

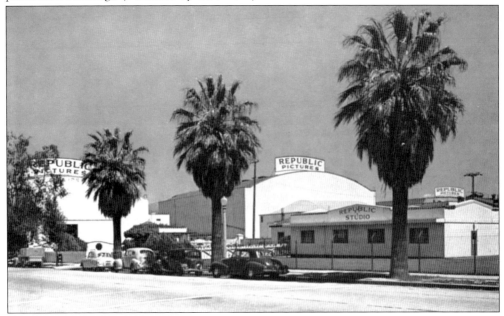

REPUBLIC PICTURES STUDIO. Herbert Yates merged Monogram Pictures, Mascot Pictures, and Liberty Films in 1935 and formed Republic Pictures, which took over the old Mack Sennett lot in Studio City. It produced Westerns and serials consistently until the mid-1950s. (Published by George H. Eberhard Company.)

90

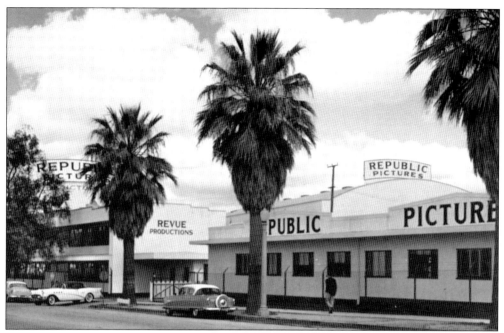

REPUBLIC'S 70 ACRES. Here is a view of the Republic Pictures lot looking north from the Radford gate to the studio. The studio was fully functional—it had 18 soundstages and a back lot that covered many genres. At the time Republic took over the lot from Mack Sennett in 1935, it covered 70 acres and reached north to the Los Angeles River. (Published by Columbia.)

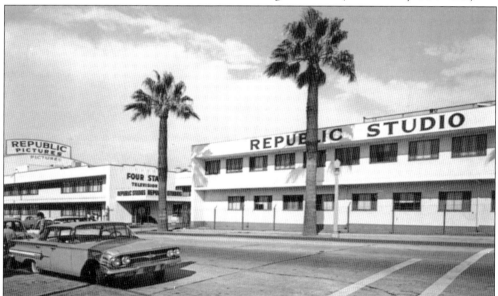

REPUBLIC'S B-PICTURES. During the 1940s, Republic Pictures produced many B-pictures and serials at their Studio City studio. The back lot had a Western street, New York street, cave set, Mexican street, miniature pool, suburban street, and several other exteriors available to produce a wide variety of looks. Republic was one of the first studios to have their film library available for television. In this card, a television company occupies a building at the front gate. (Published by Kolor Sales Ko.)

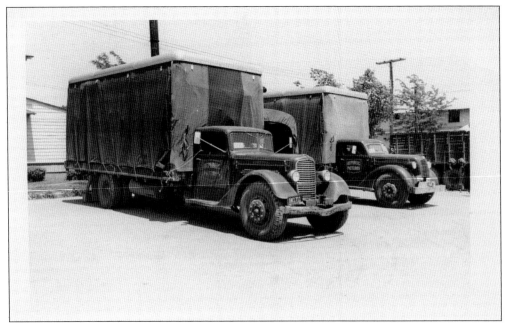

REPUBLIC PRODUCTION TRUCKS. Here is a 1940s view of two Republic Pictures trucks parked and available to assist the studio with production transportation. The canvas-covered vehicles were a necessity in making motion pictures on location. Today's "stake beds" have "tailgates" and are not covered. While on location, the electricians and grips usually make their own covers with wood, PVC, or speed rail.

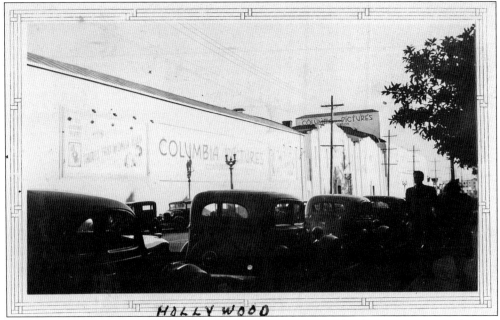

COLUMBIA PICTURES. Founded by Harry Cohn in 1924, Columbia Pictures, seen here in 1939, was located on Sunset Boulevard and Gower Street—an area called Poverty Row in the early days of Hollywood. Frank Capra directed his finest films on this lot, and Rita Hayworth never looked more beautiful than when she worked here.

Eight

RADIO AND TELEVISION

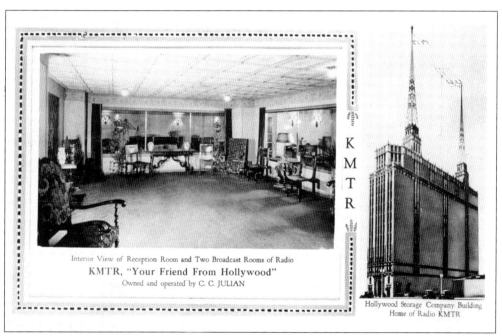

Interior View of Reception Room and Two Broadcast Rooms of Radio

KMTR, "Your Friend From Hollywood"

Owned and operated by C. C. JULIAN

Hollywood Storage Company Building
Home of Radio KMTR

KMTR. Two broadcast rooms for KMTR were located in the Hollywood Storage Company Building on Melrose Avenue in the 1920s. This is an interior view of the radio station owned and operated by C. C. Julian. KMTR later moved to a new facility, a Spanish hacienda-style building, on Cahuenga Boulevard.

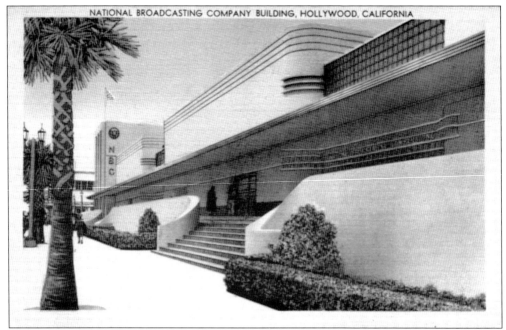

NBC BUILDING. The National Broadcasting Company opened this West Coast Radio City facility in 1938 on land that was previously used by the Famous Players–Lasky movie studios. Hollywood replaced San Francisco as the network's radio programming center on the West Coast. (Published by Calendars by Crane.)

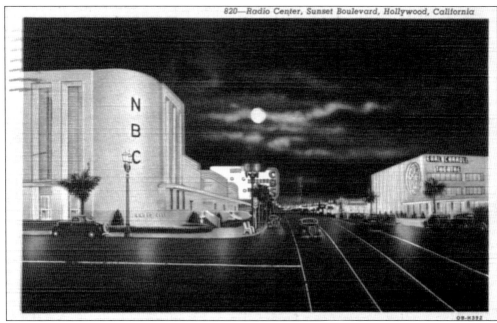

820—Radio Center, Sunset Boulevard, Hollywood, California

EARLY RADIO AND TELEVISION. A full moon helps reveal NBC Radio City, CBS Columbia Square, and the Earl Carroll Theatre in the late 1930s. The corner of Sunset Boulevard and Vine Street was the center of Hollywood's radio and television production because a handful of studios were all within a few blocks of each other. (Published by C. T. Art-Colortone.)

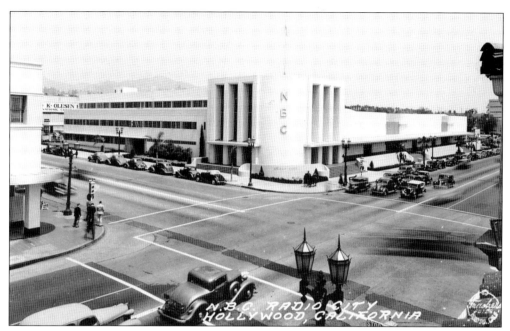

NBC Radio City, Hollywood. Here is a view looking east at the newly built NBC Radio City Building. North of the building is the Otto K. Olesen Company Limited, located where Paramount Pictures once had stages and production offices. Olesen was founded in 1905 and has provided theatrical equipment and supplies since 1906. (Published by Frashers Inc.)

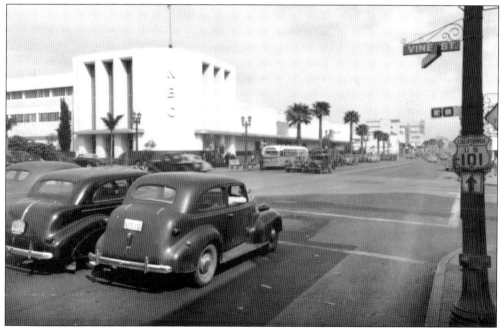

Sunset and Vine. This is an eastern look at the corner of Sunset Boulevard and Vine Street in 1945. The NBC Radio City Building on the left side of the card was the western headquarters for the "World's Greatest Broadcasting System." A three-story lobby welcomed visitors, and the building housed four audience studios on the right side.

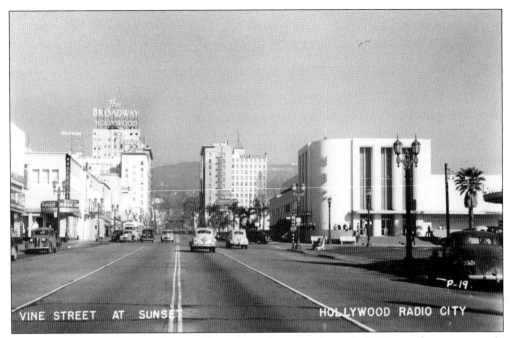

VINE STREET AT SUNSET: RADIO CITY. Vine Street in the early 1940s was home to a wide variety of entertainment. A group of sailors can be seen in front of the NBC Radio City Building on the right side of this card. Radio and television studios, movie studios, theaters, movie theaters, restaurants, hotels, and shops surrounded this intersection and continue to thrive today as a major business center.

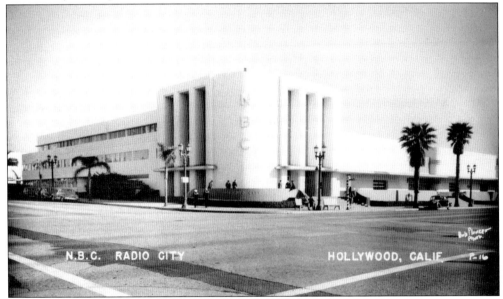

NBC RADIO CITY TOUR. A one-hour tour of NBC Radio City was offered to the public beginning in 1938. Visitors could learn how the master control board operates, hear how sound effects were created, and walk through the 300-foot Artists' Corridor, where all the talent would congregate. This tour was available for the reasonable price of 40¢. (Published by Bob Plunkett Photo.)

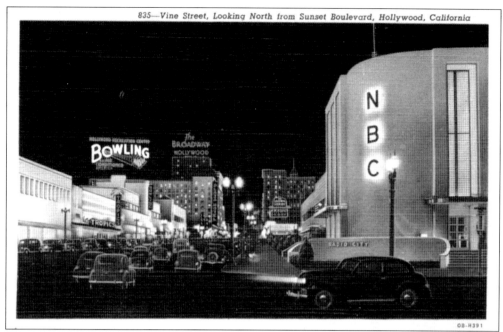

VINE STREET VIEW. In the 1940s, Vine Street, pictured here looking north from Sunset Boulevard, had a lot to offer tourists and locals who were looking for entertainment. Shopping at the Broadway Hollywood, eating at the Brown Derby or the Tropics, and bowling at the Hollywood Recreation Center were just a few things available if the neon caught your eye at night. (Published by C. T. Art Colortone.)

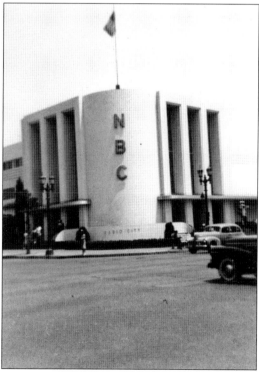

NBC's RADIO CITY IN 1943. This view of the NBC Radio City Building on Sunset Boulevard was taken in 1943; six years later, the building would launch their newest Los Angeles television station from this location. In 1964, the building was demolished, and NBC moved their West Coast television operations to Burbank. Today a bank operates from this location, and the building has movie stars outlined in tile on the western facade.

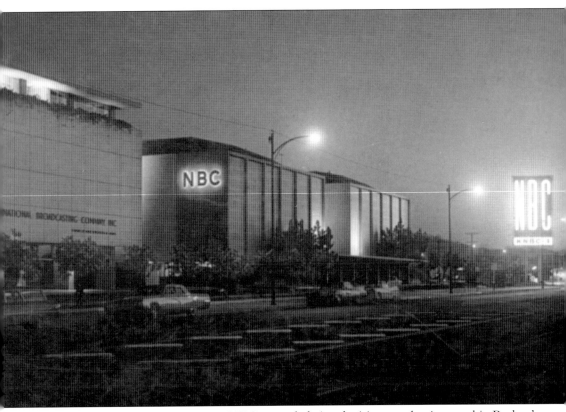

NBC's Color City Studios. NBC moved their television production to this Burbank facility in 1955. NBC's Color City Studios was the nation's first television studios built specifically for color broadcasts. NBC's parent company, RCA, was the largest manufacturer of consumer color television sets, and leading the charge of color broadcasts with this studio would surely increase product. In this mailed card from 1968, one can see NBC's buildings lined up down West Alameda Boulevard. This location houses many NBC shows, and one of the most popular is *The Tonight Show with Jay Leno*. (Published by Western Publishing and Novelty Company.)

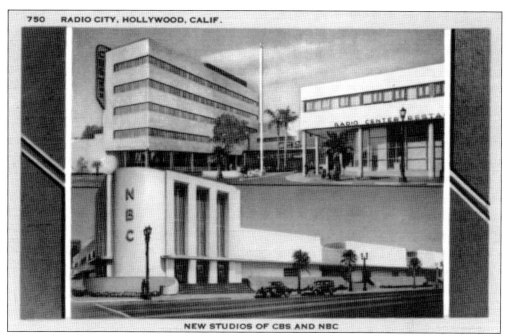

NEW STUDIOS OF CBS AND NBC

RADIO CITY LINEN CARD. This linen card from the 1940s shows rival studios CBS and NBC, which were located on Sunset Boulevard and built in the same year. Both of these studios had ultra-modern architecture and high-tech facilities that employed hundreds of Hollywood residents. During World War II, servicemen would tour these studios regularly because radio was the most available entertainment to the troops. (Published by Longshaw Card Company.)

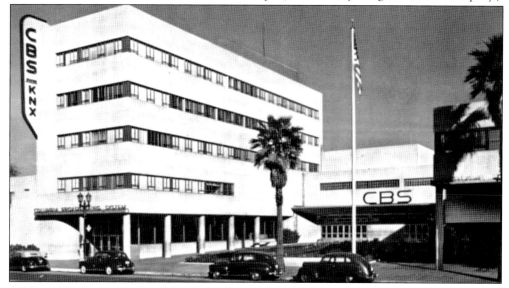

CBS IN HOLLYWOOD. In 1938, Columbia Square was home to CBS and KNX radio and television broadcasting. It took one year to construct the facility at a cost of $2 million. This corner of Sunset Boulevard and Gower Street was the site of the Nestor Film Company, Hollywood's first movie studio. On opening day, Bob Hope, Al Jolson, and Cecil B. DeMille were on hand to celebrate the Central Broadcasting System's newest West Coast headquarters. (Published by Mike Roberts Studio.)

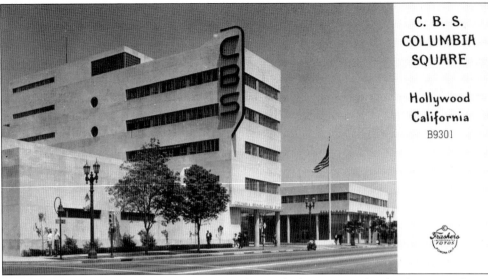

C. B. S.
COLUMBIA
SQUARE

Hollywood
California
B9301

CBS COLUMBIA SQUARE IN HOLLYWOOD. This is a look at CBS Columbia Square on Sunset Boulevard in the late 1940s. The facility originally housed eight studios, Brittingham's Radio Center Restaurant, and a conveniently located bank on the lot. William Lescaze designed Columbia Square in an international modernist style that included porthole windows and streamline motifs, all within a modern broadcasting studio that still stands today. (Published by Frashers Inc. Fotos.)

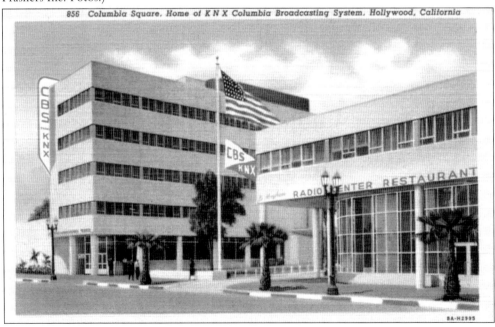

856 Columbia Square, Home of K N X Columbia Broadcasting System, Hollywood, California

HOME OF KNX COLUMBIA BROADCASTING SYSTEM. The CBS Columbia Square faces Sunset Boulevard to the south, Selma Avenue to the north, Gower Street to the east, and El Centro to the west. This central location is a hot topic with developers because of Hollywood's building revival and the threat of tearing down this structure. A proposed residential and commercial venture has been discussed ever since the purchase of the lot for $66 million in August 2006. (Published by Western Publishing and Novelty Company.)

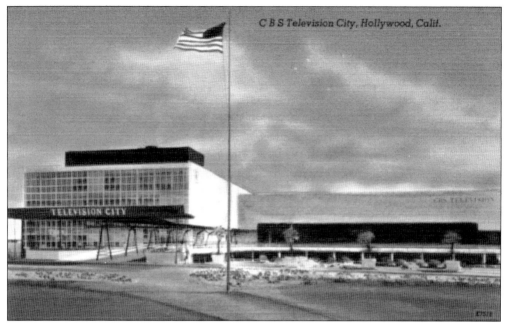

CBS Television City, Hollywood. CBS Television City, built in 1952, is located on Fairfax Avenue and Beverly Boulevard. It was designed by Pereira and Luckman and originally housed four soundstages built at ground level. The studio was built on the site of the old Gilmore Stadium, which hosted football and midget car racing until it was demolished for Television City. This is also where Elvis Presley taped his first performance for *The Ed Sullivan Show* in 1956. (Published by A. Mitcock and Sons.)

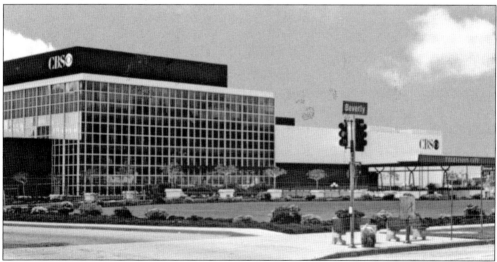

Columbia Broadcasting Studio. In the mid-1980s, two more stages were built when the CBS Expansion Program designed an annex to Television City. Soon after the annex was completed, a rehearsal hall and main building were converted to two more stages. Several more buildings and stages were built in 1991, and the complex continues to be a central production center for CBS. This lot also is a popular tourist attraction because of the close proximity to the World's Famous Farmer's Market and the Grove on Fairfax Avenue. (Published by Columbia.)

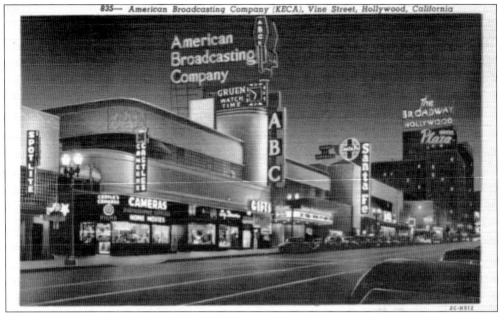

AMERICAN BROADCASTING COMPANY (KECA). In 1937, the American Broadcasting Company built their first studio on the West Coast on Vine Street between Selma Avenue and Sunset Boulevard. The ABC Television Center in East Hollywood was created in 1948 when the old Vitagraph Studios was purchased by ABC and transformed into a modern television broadcasting facility. Luckily this facility was saved from demolition in 2002 and is now incorporated within the complex on the southwest corner of Sunset Boulevard and Vine Street. (Published by Western Publishing and Novelty Company.)

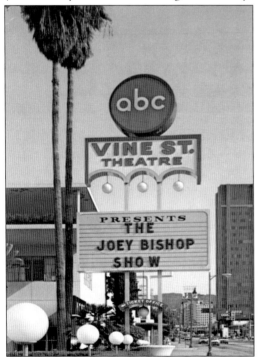

ABC VINE STREET THEATRE. In the late 1960s and early 1970s, this building was operated by ABC and called the Vine Street Theatre. Famous shows taped here were *The Joey Bishop Show*, featuring a young Regis Philbin, and a game show called *Password*. ABC also used the facility as the headquarters for broadcasting the 1984 Olympics. (Published by Krieg Publishing Company.)

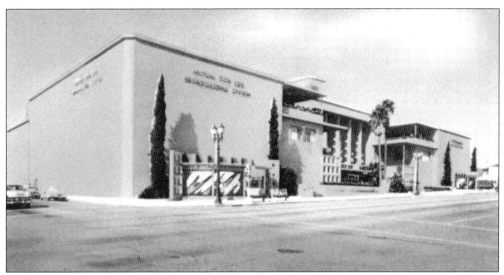

MUTUAL DON LEE TELEVISION-RADIO STUDIO. Three million dollars were spent to build the Mutual Don Lee Studios located on Vine Street in Hollywood. The lot covered three acres and was built exclusively as a state-of-the-art radio and television broadcasting studio. This studio, designed by Claude Beelman and Herman Spackler, was dedicated on August 18, 1948, after breaking ground in 1947. (Published by Gardner-Thompson Company.)

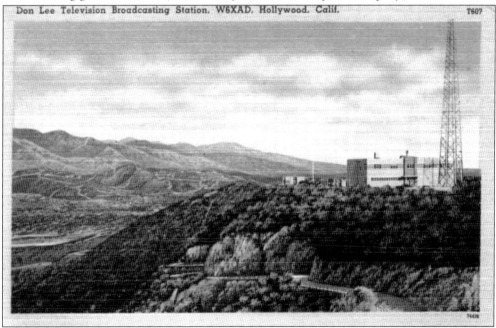

DON LEE TELEVISION BROADCASTING STATION, W6XAD. Don Lee died in 1934, but five years later, his son Thomas S. Lee continued his father's work and built this station in 1939, just above the "Hollywood" sign. This art-moderne station was a television tower and transmitter building. It was the first station designed specifically for television, and it had a pool for employees and the best view in town from "Mount Lee." The site is still used today for emergency communications by the City of Los Angeles. (Published by Tichnor Art Company.)

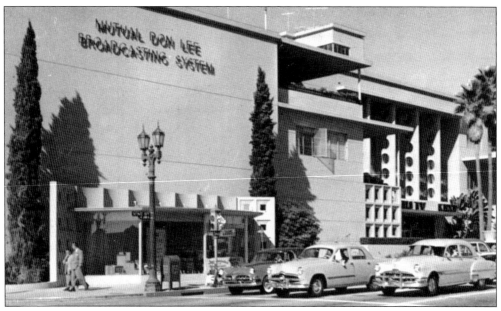

THE MUTUAL DON LEE BROADCASTING SYSTEM. Don Lee applied for the first television station permit on the West Coast in 1930. Lee, a visionary, was a Cadillac dealer and owned KHJ. This building is the oldest surviving structure in Hollywood built specifically for television broadcasting. During the course of construction, acoustical measurements were taken several times for the purpose of having "tailor made" acoustical characteristics of the studios. (Published by Mitcock and Sons.)

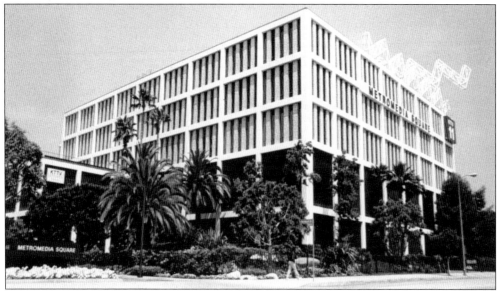

METROMEDIA SQUARE. Edward Nassour purchased a four-acre lot on Sunset Boulevard, and construction for Nassour Studios began in 1946. Four stages were built along with a projection room, dressing rooms, and production offices. Donald Crisp, Orson Welles, and Paul Henreid all had offices at the studio at one point. KTTV Channel 11 bought the studio in 1950 and added two mores stages. In 2003, the studio was torn down to make way for Central Los Angeles High School No. 1.

Nine

QUIET ON THE SET

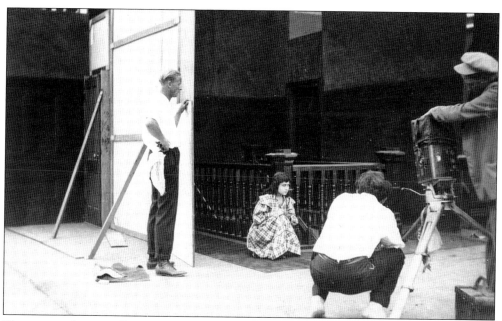

UNIVERSAL STUDIOS PRODUCTION. This is a scene being filmed at Universal City in 1915 on the biggest stage in the world. All that was needed was a camera, a director, a cameraman, an actor, a few set walls, and a laborer to get this film shooting.

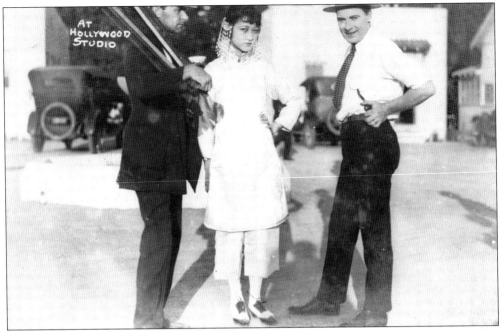

A HOLLYWOOD STUDIO. A film crew poses for a photograph in this card from the Fox Studios on Sunset Boulevard and Western Avenue around 1918. The man on the left is holding camera "sticks," which hold the camera in place.

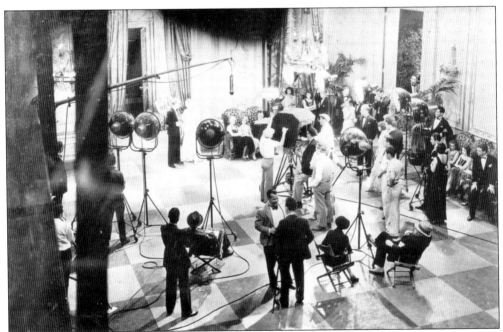

UNIVERSAL STUDIOS CAMERA SETUP. Ten 500-watt "scoop lights" surround this set at the Universal Studios lot in the 1940s. A Mole Richardson camera gear holds the camera in place in the center of the card as cast and crew wait to film the scene.

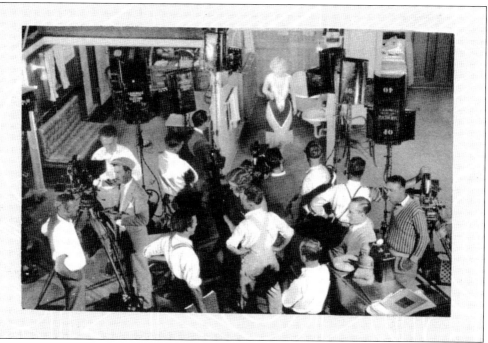

INSIDE A MOVIE STUDIO. Here is a look inside of the Cecil B. DeMille Studios in the early 1920s with a three-camera setup. The double broad lights are stamped with the DeMille logo and surround the talent in this interior scene on stage.

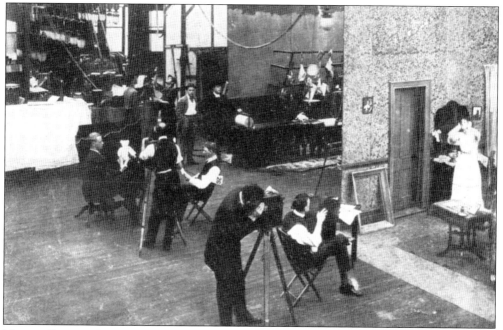

MOVIE STUDIO INTERIOR. Two scenes are being shot simultaneously in this early silent film–era view. Electricians hoist up an arbor system of lights in top left of this card. Artificial lighting began early in cinema, but the productions still relied on the sun for exterior filming.

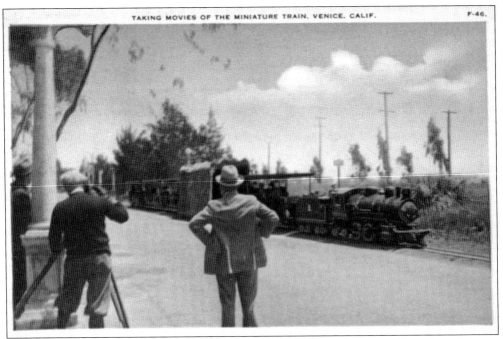

TAKING MOVIES OF THE MINIATURE TRAIN, VENICE. Here a crew films the miniature train in Venice, California. The Venice Miniature Railway began in 1900s and encircled the town. Several Prairie-type locomotives were in operation for the public until 1939. (Published by Pacific Novelty Company.)

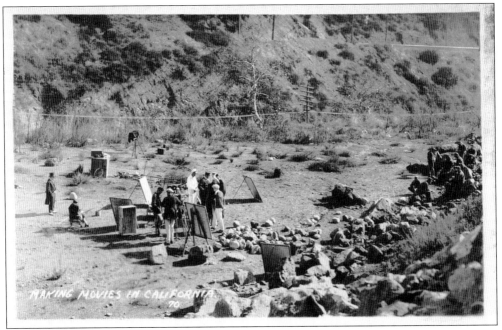

MAKING MOVIES IN CALIFORNIA. This movie, filmed outdoors during the day in California shortly before 1920, shows three cameras available for the war film. Five reflectors are used to bounce light onto the actors. Note how the reflectors have been set up using wood.

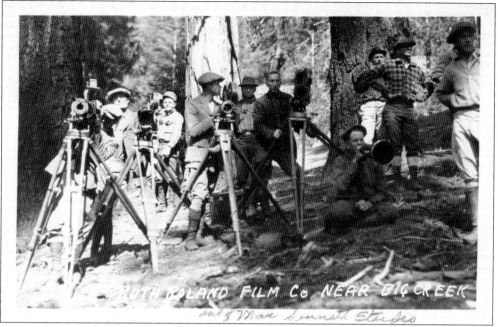

RUTH ROLAND FILM COMPANY NEAR BIG CREEK. The Mack Sennett Company was out on location for the Ruth Roland Film Company at the time this card was mailed on October 21, 1921. Four cameras on "sticks" are up and ready for action for this silent-film production.

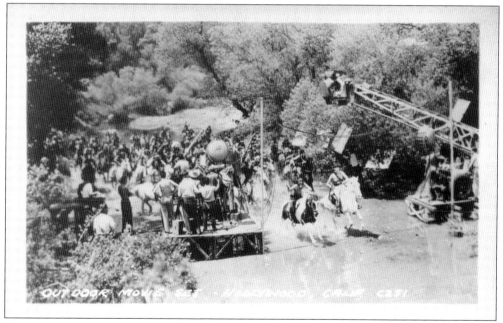

OUTDOOR MOVIE SET, HOLLYWOOD. This is a view of a day exterior shoot of a cowboys and Indians film. Two platforms have been built to elevate the lights and cameras on both sides of the charging talent. A camera crane is armed and over the opening to get a high-angle shot. There are two poles attached to the platforms that provide a "tie off" point for power cables to energize the lights and cameras. (Published by Views, Inc.)

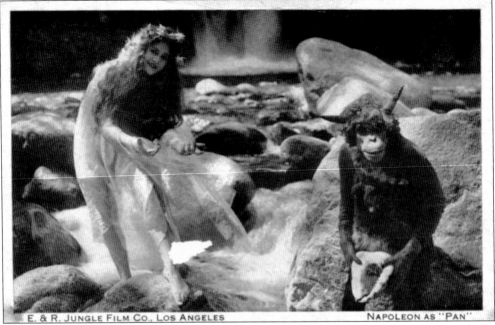

E & R JUNGLE FILM CO., LOS ANGELES NAPOLEON AS "PAN"

E & R JUNGLE FILM COMPANY, LOS ANGELES. The E & R Jungle Film Company had a studio in Los Angeles that provided production companies with a miniature jungle set right in the middle of the city. Here Napoleon, an orangutan, plays "Pan." (Published by George and Sons, Printers.)

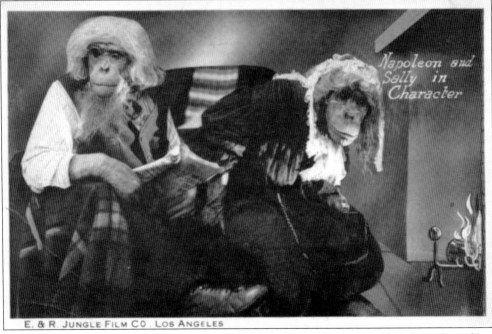

E. & R. JUNGLE FILM CO, LOS ANGELES

MONKEYING AROUND FOR E & R JUNGLE FILM. In the 1920s, the Napoleon short films were very successful for the E & R Jungle Film Company. Here are Napoleon and Sally in "character" for a production shot at the studio. (Published by George and Sons, Printers.)

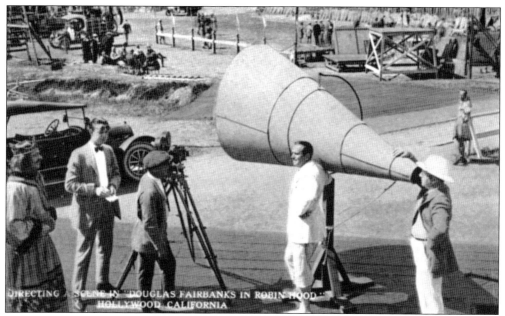

ROBIN HOOD IN HOLLYWOOD. In 1922, Allan Dwan directs a scene for *Robin Hood*, which was filmed at the Pickford Fairbanks Studios. The budget was $1.5 million and had some of the biggest sets ever built in Hollywood. Arthur Edeson was the director of photography, and he would go on to shoot *The Maltese Falcon* and *Casablanca*, two of the most famous films of the 1940s. (Published by Western Publishing and Novelty Company.)

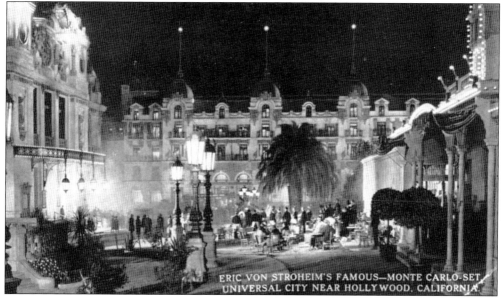

MONTE CARLO SET. Erich von Stroheim directed *Foolish Wives* for Universal in 1922 at a cost of $1.5 million. This set was an exact duplicate of the Monte Carlo gambling resort and built within the specifications of von Stroheim, who knew this area of Monte Carlo very well and wanted complete authenticity. Rumor has it that scenes with background artists drinking out of champagne glasses actually had champagne in them. (Published by Western Publishing and Novelty Company.)

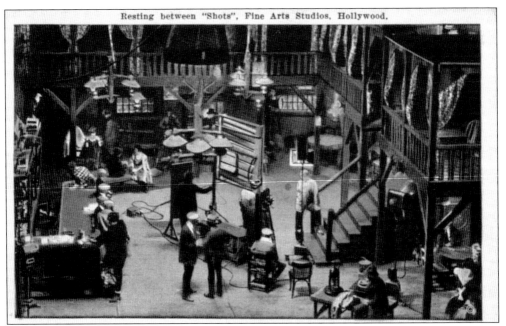

FINE ARTS STUDIOS, HOLLYWOOD. Strangely enough, the Fine Arts Studios lasted less than two years; however, the films produced by the company will live on forever because of production head D. W. Griffith. This studio was located at 4500 Sunset Boulevard where Hollywood Boulevard and Hillhurst intersect. At this time, the studio had 209 buildings, including three open-air stages, a glass-enclosed studio, and a back lot with three prominent exterior sets. (Published by California Postcard Company.)

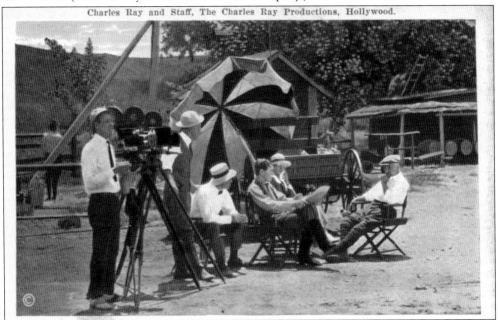

Charles Ray and Staff, The Charles Ray Productions, Hollywood.

CHARLES RAY PRODUCTIONS. Seen here in this early-1920s card, Charles Ray and his staff discuss the next "shot." Ray took over the old Kalem lot but went bankrupt in 1923. The studio went on to become Monogram Pictures. (Published by California Postcard Company.)

112

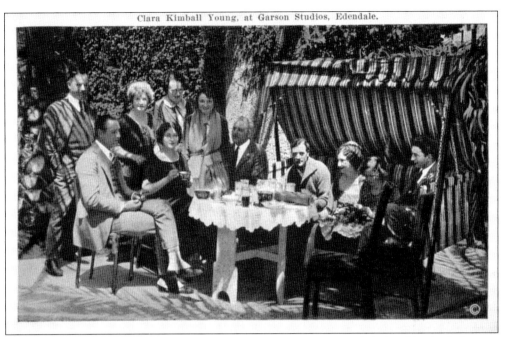

CLARA KIMBALL YOUNG, GARSON STUDIOS. When William Fox left the old Selig Polyscope lot, Clara Kimball Young took over the studio and renamed it Garson Studios. Edendale (now Silver Lake) would be the host to several studios, and this Mission-style movie lot would go on to produce many silent films. (Published by California Postcard Company.)

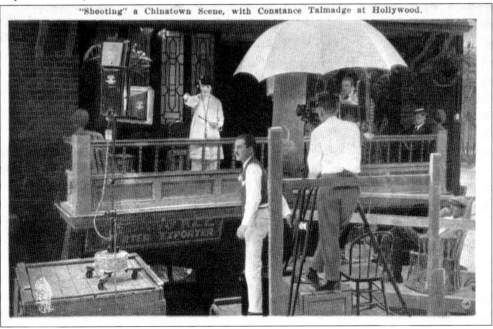

CONSTANCE TALMADGE, UNITED STUDIOS. This "Chinatown" scene was shot at United Studios shortly before Paramount took over the lot in 1926. Constance Talmadge is in line with the klieg lights, which produced enough illumination for the "key light." (Published by California Postcard Company.)

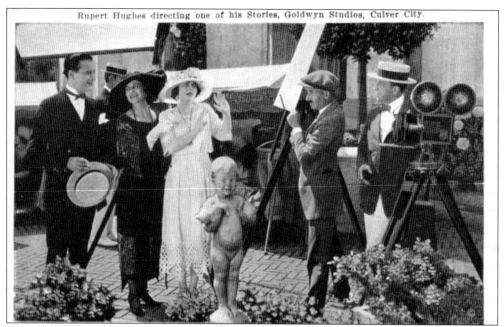

RUPERT HUGHES, GOLDWYN STUDIOS. Rupert Hughes wrote and directed Helene Chadwick in the production of *Gimme* at the Goldwyn Studios in 1922. John Mescall, the director of photography, can be seen focusing a reflector, which is bouncing light from the "sun" and giving the scene the finishing touches. Cedric Gibbons, the art director for the film, would go on to not only design the Oscar for the Academy Awards but win it himself 11 times. (Published by California Postcard Company.)

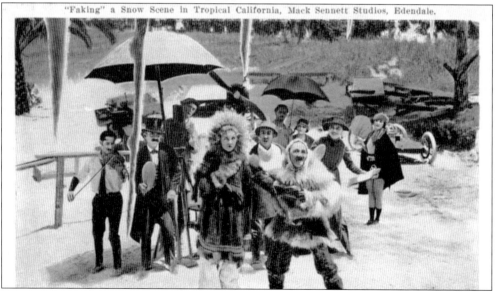

BEN TURPIN, MACK SENNETT STUDIOS, EDENDALE. A snow scene is being shot at the Mack Sennett lot in tropical California for the 1922 production of *Home Made Movies*, featuring Ben Turpin. Mood music is being played on a violin, and a wind machine is standing by to blow snow flurries into the shot. The giant icicles are made of cotton batting and the snow is produced with salt. (Published by California Postcard Company.)

HAROLD LLOYD AND MICKEY DANIELS.
In 1922, Harold Lloyd starred in *Dr. Jack*
for Hal Roach Studios under the direction
of Fred C. Newmeyer. In this scene,
Lloyd's patient, Mickey Daniels, is about to
receive a dose of medicine that "dispenses
happiness" from the bottle. (Published
by California Postcard Company.)

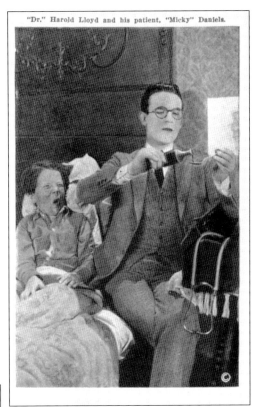

"Dr." Harold Lloyd and his patient, "Micky" Daniels.

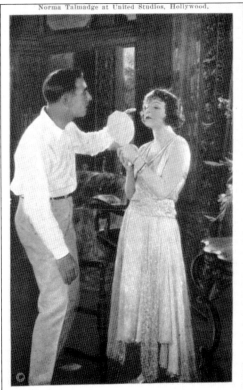

Norma Talmadge at United Studios, Hollywood,

NORMA TALMADGE, UNITED STUDIOS.
Frank Lloyd and Norma Talmadge worked
on five films together. Here, at the United
Studios in the early 1920s, Lloyd gives
Talmadge some suggestions for her makeup
before a shooting a scene. (Published
by California Postcard Company.)

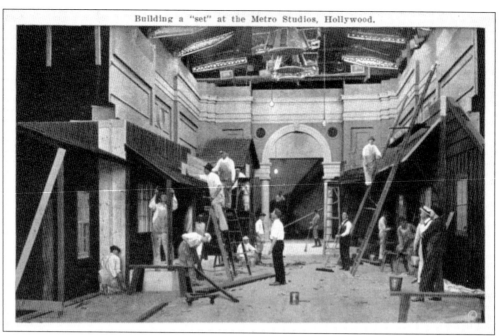

Building a "set" at the Metro Studios, Hollywood.

METRO STUDIOS. An exterior set is being constructed on an interior set at Metro Studios in 1922. Carpenters are working on erecting a mining town street scene within the confines of a palatial drawing room. The Metro Studios were owned by Marcus Loew and eventually merged into Metro-Goldwyn-Mayer in 1924. (Published by California Postcard Company.)

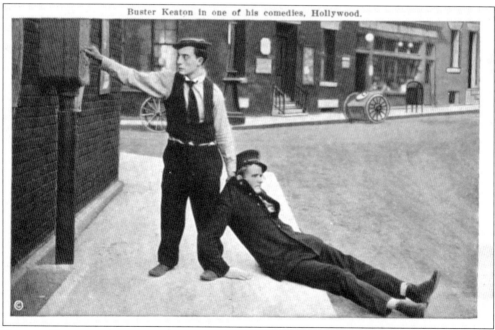

Buster Keaton in one of his comedies, Hollywood.

BUSTER KEATON, HOLLYWOOD. Buster Keaton wrote, directed, and starred in *Cops*, one of Keaton's most popular short films. It teamed him with Elgin Lessley, his cinematographer on 23 films. (Published by California Postcard Company.)

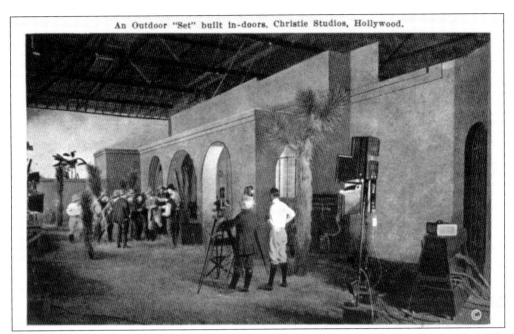

An Outdoor "Set" built in-doors, Christie Studios, Hollywood.

CHRISTIE STUDIOS. Here is an exterior scene filming onstage at Christie Studios in 1922. An early "spider box," an electrical distribution system, can be seen on the bottom right of the card. This system enabled the klieg lights to receive DC power to illuminate the scene, creating a "day" look on the set. (Published by California Postcard Company.)

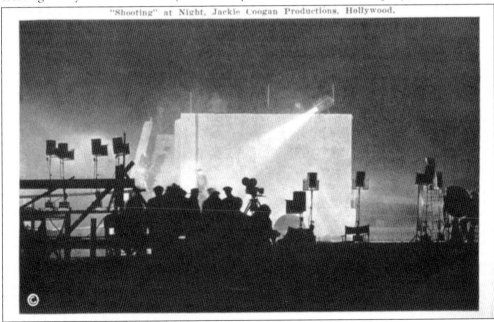

"Shooting" at Night, Jackie Coogan Productions, Hollywood.

JACKIE COOGAN PRODUCTIONS, HOLLYWOOD. This London fog scene from *Oliver Twist* is being shot for Jackie Coogan Productions in 1922. In 1939, after making $4 million as a child actor, Coogan filed a lawsuit against his mother and stepfather to collect his earnings but was awarded only $126,000. California legislature passed the Coogan Act soon after, requiring parents to set aside 15 percent of a child's earning in a trust. (Published by California Postcard Company.)

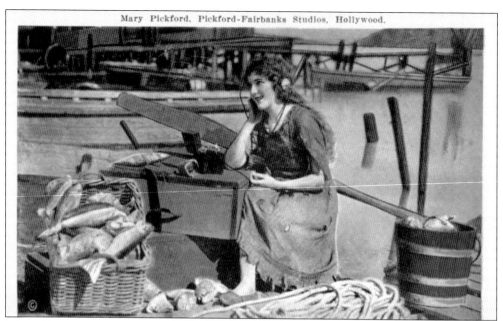

MARY PICKFORD, PICKFORD-FAIRBANKS STUDIOS. Mary Pickford, "America's Sweetheart," is pictured here making a radiophone transmission in 1921 on the set of *Tess of the Storm Country*. This was Pickford's second production of the film. The first, in which she also starred, was shot in 1914. Eight years later, Charles Rosher, the cinematographer, would go on to win the first academy award for cinematography for *Sunrise*. (Published by California Postcard Company.)

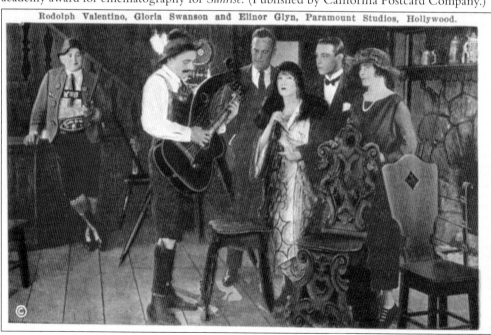

PARAMOUNT STUDIOS. Rudolph Valentino and Gloria Swanson starred in *Beyond the Rocks* with Sam Wood at the helm. Elinor Glyn, the writer of the novel, is standing to Valentino's left in this card promoting the Paramount production from 1922. (Published by California Postcard Company.)

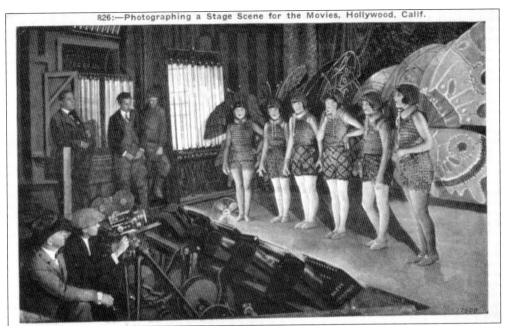

BETTY COMPSON PRODUCTIONS. A dance routine is being filmed for this scene, taking place on a stage somewhere in Hollywood in the 1920s. This card was mailed in 1934, but it dates back to over 10 years earlier when Betty Compson Productions made three films. (Published by M. Kashower Company.)

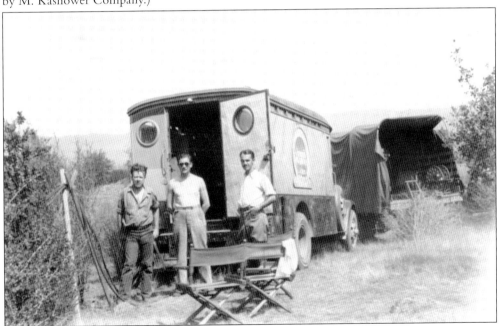

PARAMOUNT TRUCK ON LOCATION. Here Paramount Pictures Sound Truck No. 15 is on location, with three members of the crew standing at the back of the main truck. An auxiliary truck is seen in the background. The cable spools on the auxiliary truck assist both the sound and electric departments. They hold several hundred feet of cable, which makes it easier to "rig" and "wrap" at the beginning and end of a shoot.

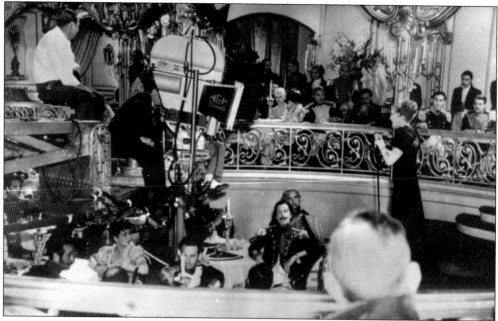

MGM Studios Set. Jeanette MacDonald was one of Louis B. Mayer's favorite actresses on the Metro-Goldwyn-Mayer lot. Here she is pictured in the late 1930s on a period film with dozens of background extras in the scene. The camera crane is boomed into the set and holds the camera operator, the first assistant cameraman (focus puller), and two fill lights.

INDOOR MOVIE SET, METRO-GOLDWYN-MAYER PRODUCTION
CULVER CITY, CALIF. ARTCO 597

Spencer Tracy at Metro-Goldwyn-Mayer. This is a view inside one of the stages at Metro-Goldwyn-Mayer Studios in Culver City. Spencer Tracy is waiting for his cue to walk into frame on the front porch. A sound boom is visible in the middle of the card at top, and the camera is located at right. Several electricians and grips are standing by off camera next to the lights. (Published by Artco.)

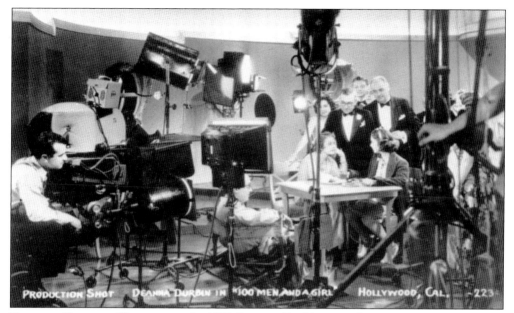

DEANNA DURBIN, UNIVERSAL. In 1937, Deanna Durbin starred in *100 Men and A Girl* for Universal. Henry Koster directed this vehicle with Joseph Valentine acting as cinematographer. Valentine's personal light can be seen "camera right," with his name on it, providing additional fill light to the scene. Valentine would go on to win the Academy Award for color cinematography in 1948 for *Joan of Arc*, which he shared with two other cameramen.

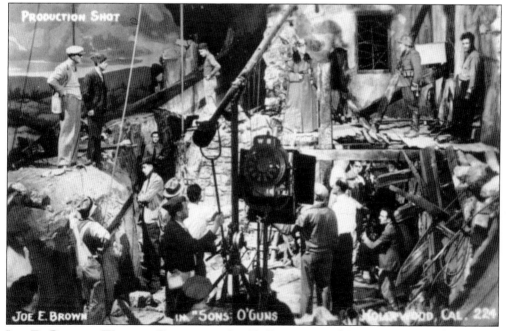

JOE E. BROWN, WARNER BROTHERS. Joe E. Brown starred in *Sons O' Guns* for Warner Brothers in 1936, playing the role of World War I–hero Jimmy Canfield. Dozens of camera, grip, electric, and sound department crew members are pictured inside one of stages on the Burbank lot.

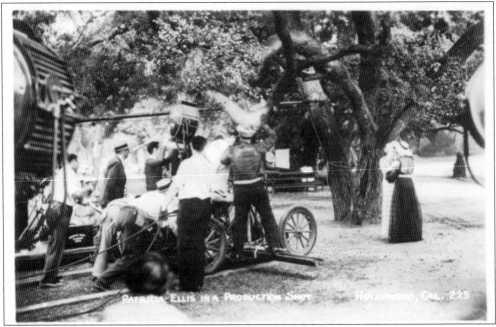

PATRICIA ELLIS, WARNER BROTHERS. A camera dolly tracks in for a shot on the set of *Freshman Love* in this 1936 view on location. William McGann directed this musical for Warner Brothers, with Patricia Ellis playing the role of Joan Simpkins. Several beam projector lights are on the dolly, operated by electricians, while the grips push the camera closer to the cast.

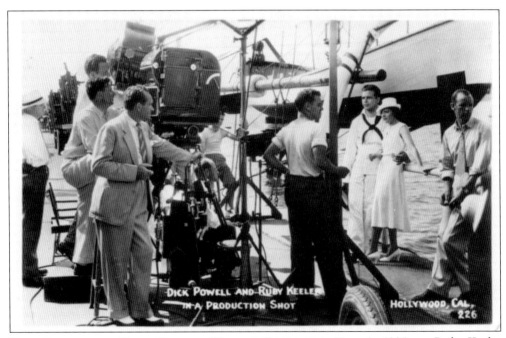

DICK POWELL AND RUBY KEELER, WARNER BROTHERS. Here, in 1935, are Ruby Keeler and Dick Powell on the set of *Shipmates Forever*. Frank Borzage, the director of the film standing near the camera with the striped tie, looks towards his crew.

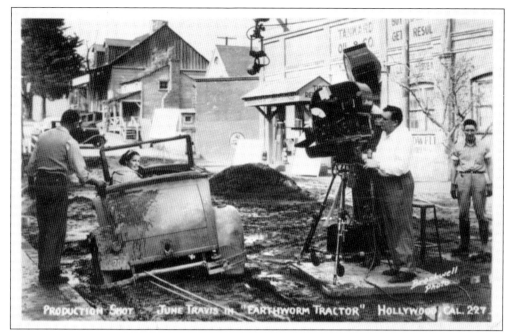

JUNE TRAVIS, WARNER BROTHERS. Warner Brothers produced *Earthworm Tractors* in 1936 starring Joe E. Brown and June Travis. This is a production shot of a muddy scene filmed on the back lot. A First National beam projector is right of the camera, and a sound microphone is boomed into the shot. (Published by Brookwell Photo.)

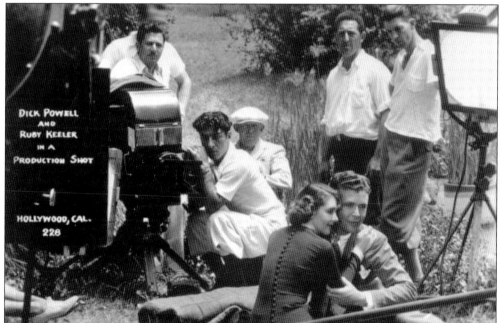

POWELL AND KEELER AT WARNERS. Warner Brothers produced two films featuring Dick Powell and Ruby Keeler between 1935 and 1936, *Colleen* and *Shipmates Forever*. This production shot features both Powell and Keeler with the camera and electric departments capturing the scene on film.

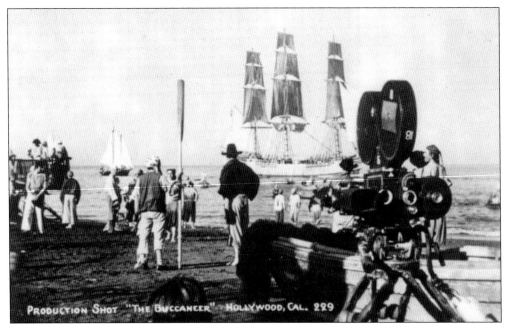

DeMille at Paramount. Cecil B. DeMille directed *The Buccaneer* for Paramount in 1938 and produced it again in 1958 with son-in-law Anthony Quinn directing. This view of the earlier version shows full-size ships in the background. Location work included Catalina Island and Hawaii for this epic about the pirate Jean Lafitte.

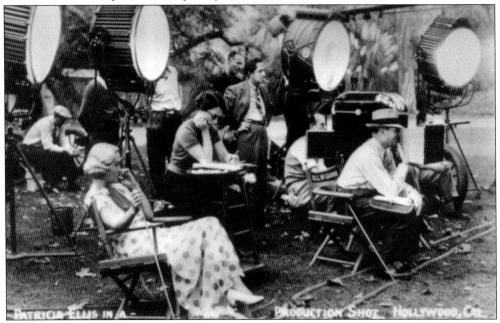

More Patricia Ellis, Warner Brothers. In 1936, Patricia Ellis starred in *Freshman Love* for Warner Brothers. Here is a view of the set behind the camera. The director, William C. McGann, patiently waits for everything to be ready as his script supervisor/continuity assistant stands behind him. Ellis is sitting in a director's chair, on the left, taking a smoke break. Four beam projectors are illuminating the scene, and the camera is low and left of McGann.

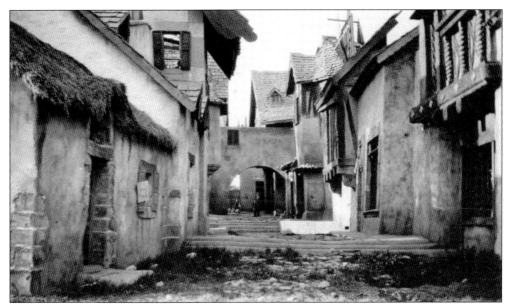

UNITED STUDIOS. This studio, which began as the Paralta Studios in 1917, was eventually taken over by Robert Brunton. When the studio changed hands again in 1921, it was called United Studios, and at the time, it had seven closed stages. While this lot was still United Studios, George Fitzmaurice shot the first dark set stage interior for Technicolor in his 1924 film *Cytherea*. The United Studios back lot included an eastern street, a slave market, and European street sets. In 1926, Paramount took over the lot and put money into its stages and infrastructure.

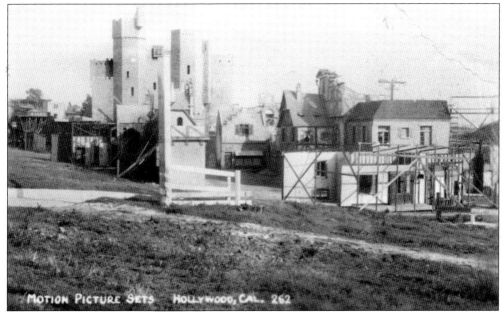

MOTION PICTURE SETS, HOLLYWOOD. This is a look at a city or village built in the back lot of a movie studio in the late 1930s. It seems to be a European street or European village, including a café and castle. Today's permanent exterior sets are more complex and have catwalks and support for camera, lighting, and grip.

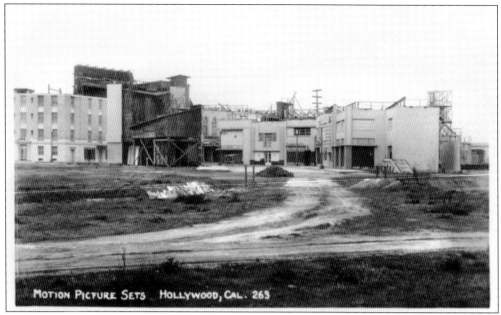

MOTION PICTURE BACK LOT. Here are more motion picture sets in the back lot of a Hollywood movie studio. These sets look more modern than the ones in the previous image and seem to be of a city street or New York street. Many of the New York exterior sets have working streetlights and places for steam to come out of the street to make it look like a subway is underneath.

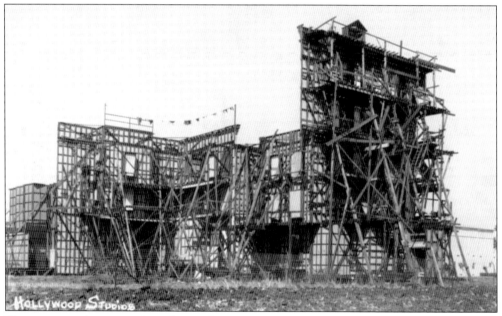

HOLLYWOOD STUDIOS. A Hollywood movie set is sometimes only a facade. With a quick look, this image can be mistaken for a gathering of wasted lumber. It's actually a massive movie set facade on a back lot of a movie studio in Hollywood in the 1920s. Hollywood still builds these enormous sets today because if they build them the audiences will come and movies will continue to flourish in the 21st century.

BIBLIOGRAPHY

Behlmer, Rudy. *Inside Warner Brothers (1935–1951)*. London: Weidenfeld and Nicolson, 1986.

Berg, A. Scott. *Goldwyn, A Biography*. New York: Knopf, 1989.

Capra, Frank. *The Name Above the Title*. New York: Macmillan, 1971.

Cerra, Julie Lugo. *Culver City, The Heart of Screenland*. Chatsworth, CA: Windsor Publications, 1992.

Chaplin, Charlie. *My Autobiography*. New York: Simon and Schuster, 1964.

Crowther, Bosley. *Hollywood Rajah, The Life and Times of Louis B. Mayer*. New York: Holt, Riehart, Winston, 1960.

Daggett, Dennis. *The House That Ince Built*. Glendale, CA: Great Western Publishing, 1980.

Haver, Ronald. *David O. Selznick's Hollywood*. Bonanza Books, 1980.

Hay, Peter. *When the Lion Roared*. Atlanta, GA: Turner Publishing, Inc., 1991.

Hirschhorn, Clive. *The Universal Story*. New York: Crown Publishers, 1983.

Horne, Gerald. *Class Struggle In Hollywood*. Austin, TX: University of Texas Press, 2001.

Larkin, Rochelle. *Hail, Columbia*. New Rochelle, NY: Arlington House, 1975.

Parrish, Robert. *Growing Up in Hollywood*. New York: Harcourt Brace Jovanovich, 1976.

Schatz, Thomas. *The Genius of the System, Hollywood Filmmaking in the Studio Era*. New York: Pantheon Books, 1988.

Slide, Anthony. *The Kindergarten of the Movies, A History of the Fine Arts Company*. Metuchen, NJ: The Scarecrow Press Inc., 1980.

Thomas, Bob. *King Cohn*. New York: G. P. Putnam and Sons, 1967.

———. *Thalberg, Life and Legend*. Garden City, NY: Doubleday, 1969.

Warner, Jack. *My First Hundred Years in Hollywood*. New York: Random House, 1965.

Zierold, Norman. *The Moguls*. New York: Coward-McCann, Inc., 1969.

ACROSS AMERICA, PEOPLE ARE DISCOVERING SOMETHING WONDERFUL. *THEIR HERITAGE.*

Arcadia Publishing is the leading local history publisher in the United States. With more than 3,000 titles in print and hundreds of new titles released every year, Arcadia has extensive specialized experience chronicling the history of communities and celebrating America's hidden stories, bringing to life the people, places, and events from the past. To discover the history of other communities across the nation, please visit:

www.arcadiapublishing.com

Customized search tools allow you to find regional history books about the town where you grew up, the cities where your friends and family live, the town where your parents met, or even that retirement spot you've been dreaming about.